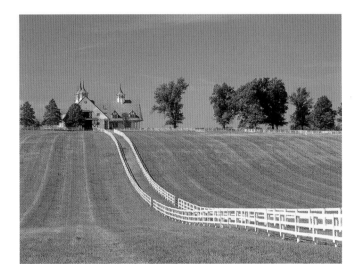

KENTUCKY

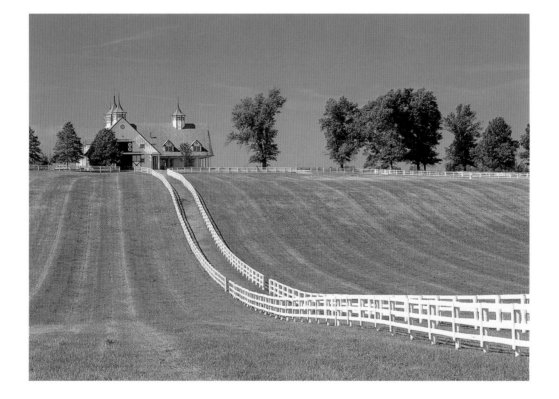

whitecap

Text by Tanya Lloyd Kyi
Edited by Elaine Jones
Photo editing by Tanya Lloyd Kyi
Proofread by Lisa Collins
Cover and interior layout by Jacqui Thomas

Printed and bound in China

National Library of Canada Cataloguing in Publication Data
Kyi, Tanya Lloyd, 1973–
 Kentucky

 (America series)
 ISBN 1-55285-416-7
 ISBN 978-55285-416-7

 1. Kentucky—Pictorial works. I. Title. II. Series
F452.K94 2003 976.9'044'0222 C2002-911392-X

The publisher acknowledges the financial support of the Government of Canada through
the Book Publishing Industry Development Program (BPIDP) and the Province of British
Columbia through the Book Publishing Tax Credit.

For more information on the America Series, please visti www.midpointtrade.com.

Ancient forests extend for hundreds of miles over mountain slopes, broken only by impassable canyons carved by wind and water. Tiny streams lead to rushing creeks, which in turn flow into enormous rivers that curve slowly through the landscape. Flood plains and marshes lie along their banks. This is what Daniel Boone saw more than two centuries ago—a territory of unmapped watersheds and forests, known only to the native people who hunted there.

The frontiersman now legendary for his musket and coonskin cap was, in the 1770s, a hunter, trapper, and ex-soldier. He embarked on an expedition to travel and map Kentucky in 1769 and within a decade, he had traveled the Cumberland Gap, created the Wilderness Road for colonists to follow, and established a fort at Boonesborough. He fathered a family of 10 children, he was captured by native raiders, and he saw the country of his birth become the United States of America.

The adventures of Daniel Boone and travelers and settlers like him echo through the land and history of Kentucky. The state's parks and preserves reverberate with the spirit of adventure—a spirit that lures hikers to Daniel Boone National Forest, boaters and campers to Land Between the Lakes National Recreation Area, spelunkers to the massive caverns of Mammoth Cave National Park. Countless bird species nest on the cliffs of the Kentucky River Palisades, and endangered plants find refuge from the threats of the twenty-first century in the protected areas of the Red River Gorge.

Home to more than 4 million people, Kentucky is no longer one expanse of wilderness. The city lights of Louisville illuminate the night sky. The thunder of hooves from the race tracks and horse farms of Lexington draw enthusiasts from around the world. Whether one travels to the historic streets of Paducah or the farmland of the Bluegrass Region, there are countless sights to discover and adventures to experience, long after the days of the frontier have faded and only legends remain.

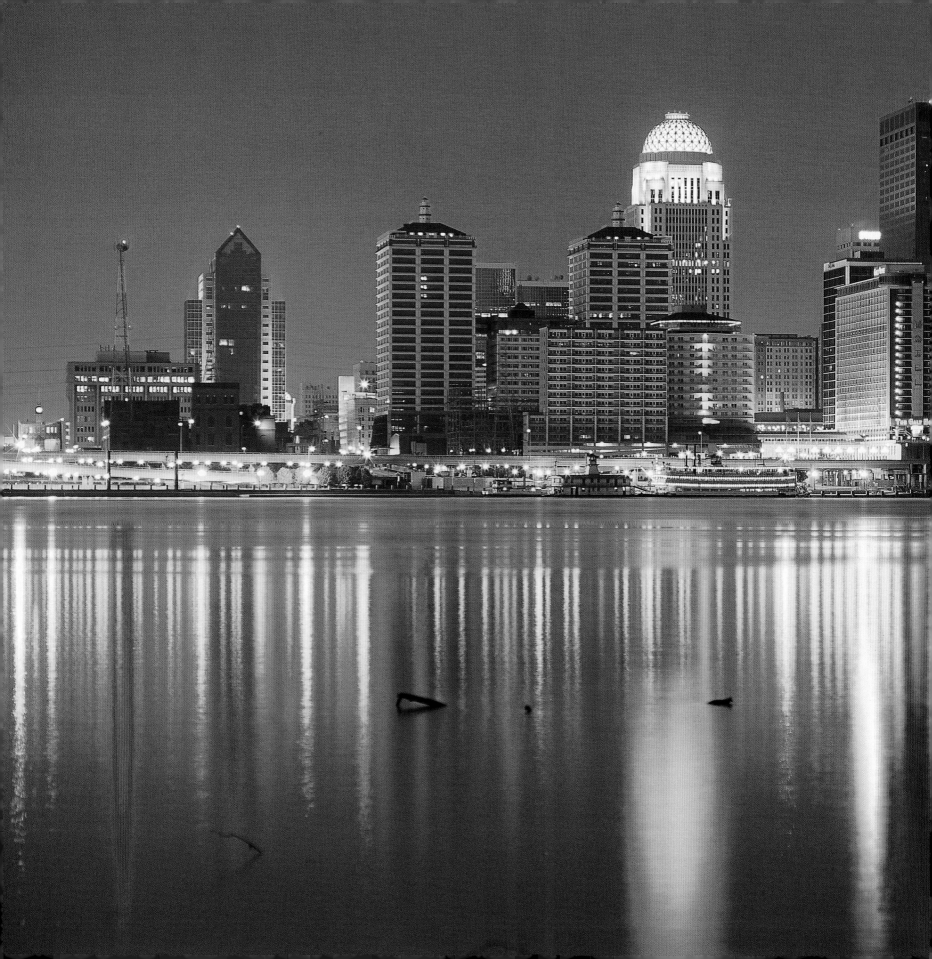

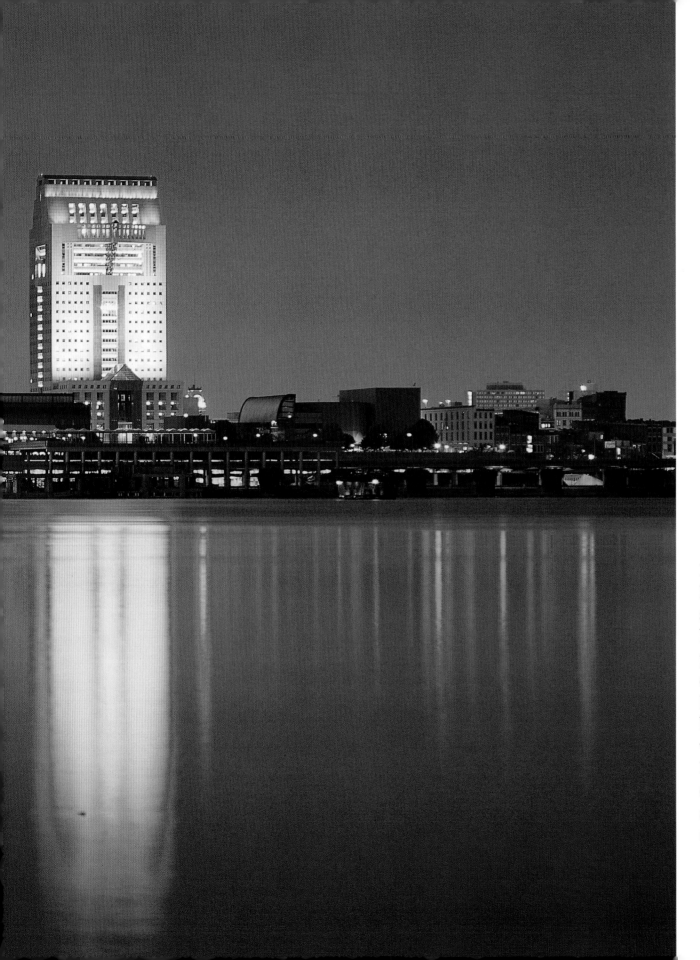

It's the home of Churchill Downs horse racing and Ohio River steamboats. It's the birthplace of chewing gum, cheeseburgers, and Louisville Slugger baseball bats. Since the city was founded in 1778, Louisville has attracted entrepreneurs, inventors, and artists to its bustling downtown streets.

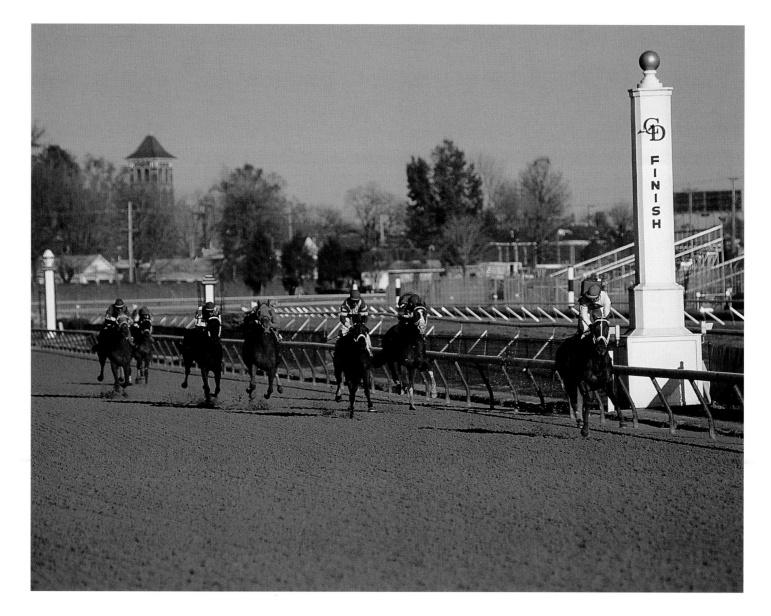

From spring meets to the Kentucky Derby in May, thousands of fans wait to hear the drumming of hooves at Churchill Downs race track in Louisville. Racing enthusiasts bet millions of dollars during the Kentucky Derby each year.

To enter the Louisville Slugger Museum, visitors stroll under the shadow of the world's largest bat—a 68,000-pound steel replica of Babe Ruth's Louisville Slugger. Bud Hillerich created the first Slugger in 1884 while employed at his family's woodworking factory. The company is still owned by Hillerich's descendants.

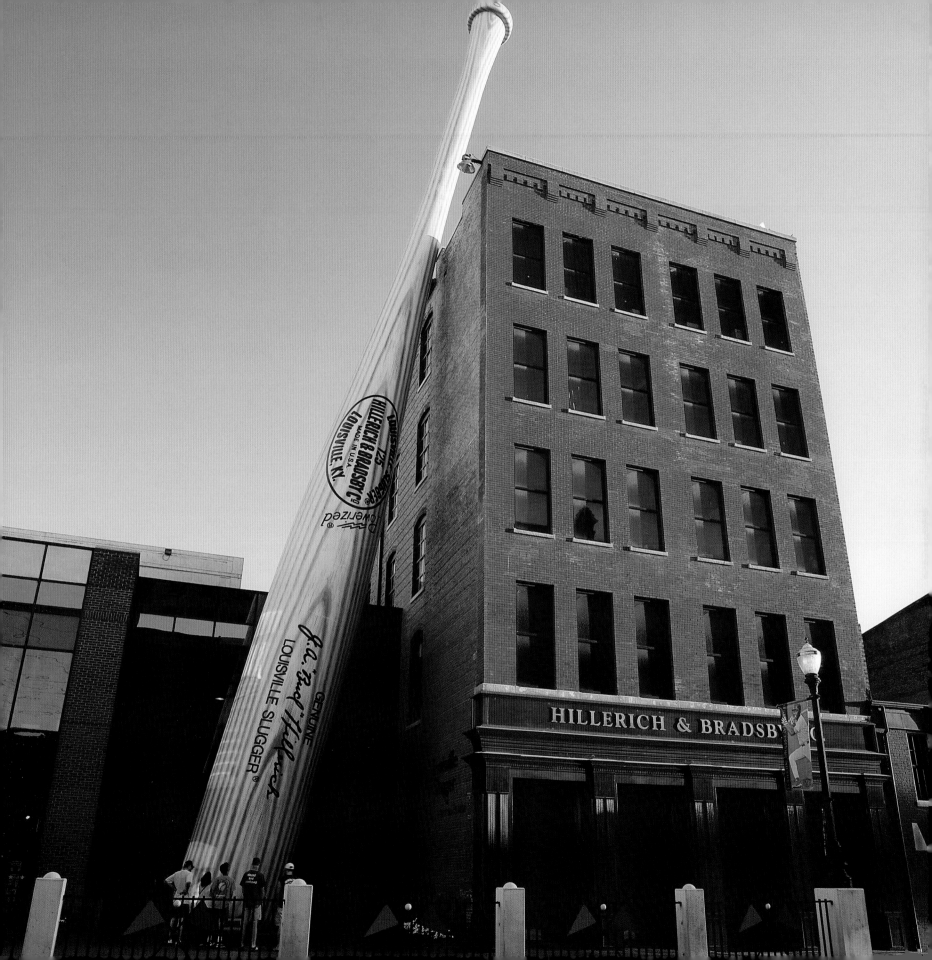

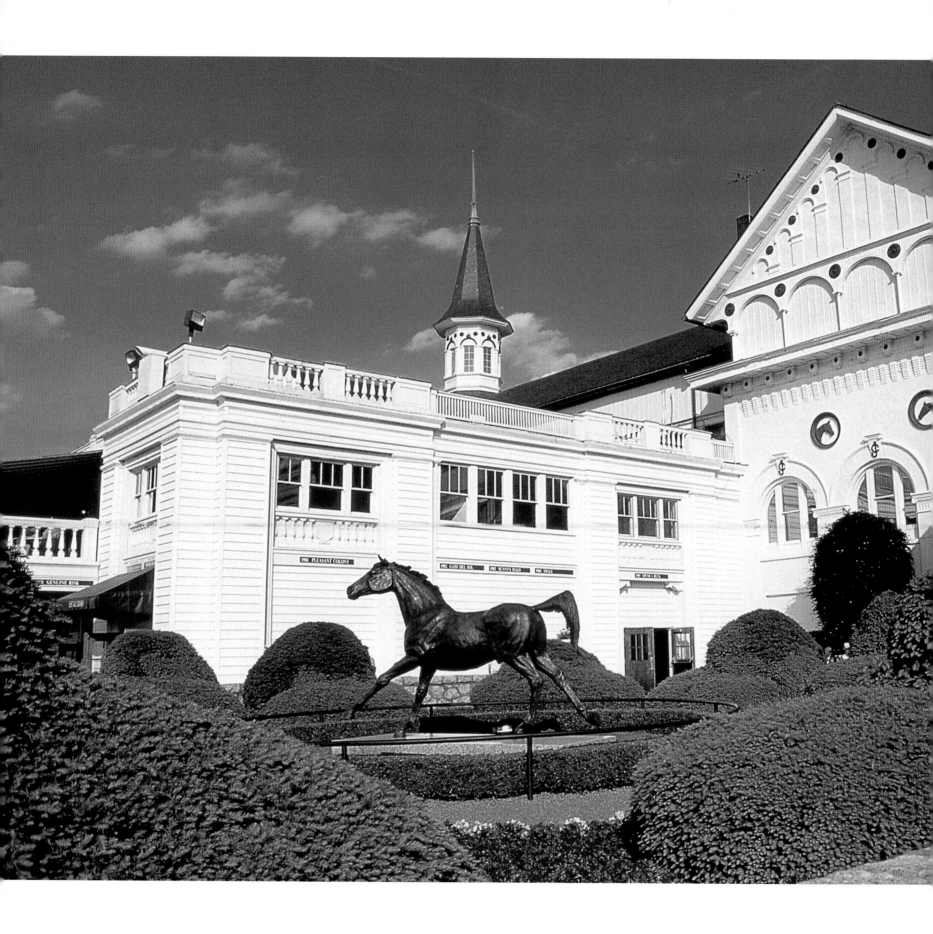

Home to the Louisville Orchestra, the Kentucky Opera, and the Louisville Ballet, the Kentucky Center is a hub of cultural activity. The center also helps to mold Kentucky's next generation of artists, through the Governor's School for the Arts. The three-week program hosts high-school students pursuing careers in writing, dance, drama, music, and theater.

Twenty-six-year-old Colonel Meriwether Lewis Clark was traveling in Europe in 1872 when he conceived of a race track in Louisville, designed to showcase Kentucky's thoroughbred breeding. By 1874, Clark was selling shares in his Churchill Downs project. The Kentucky Derby has been held every year since 1875.

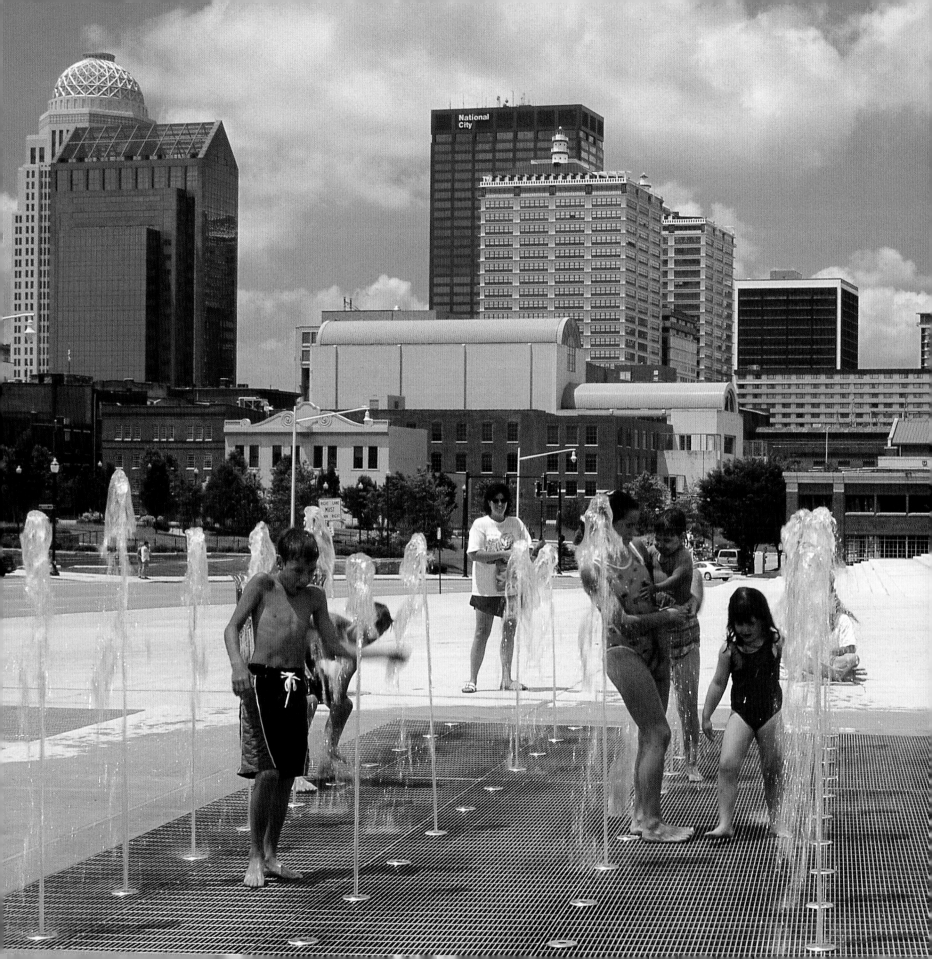

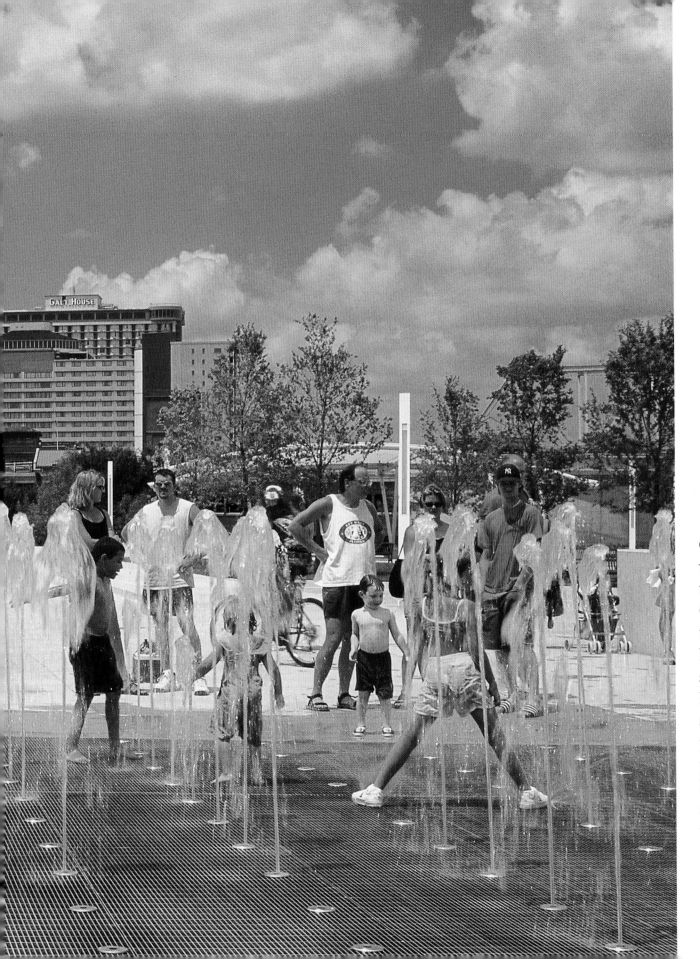

Once the domain of warehouses and industry, the banks of the Ohio River have been transformed into one of Louisville's most popular spots, Riverfront Park. Landscaped gardens, sports fields, children's play areas, jogging paths, and boat access have allowed city residents to reclaim the waterfront.

13

From the Light Up Louisville Festival each November until New Year's Day, Jefferson Square and the surrounding city streets dazzle with thousands of lights.

FACING PAGE
Louisville was founded in 1778 by Revolutionary War leader George Rogers Clark, and christened in honor of King Louis XVI of France, who supported independence. The city grew slowly, however, until the first steamboat arrived at the Ohio River docks in the early 19th century, opening Louisville to industry and trade.

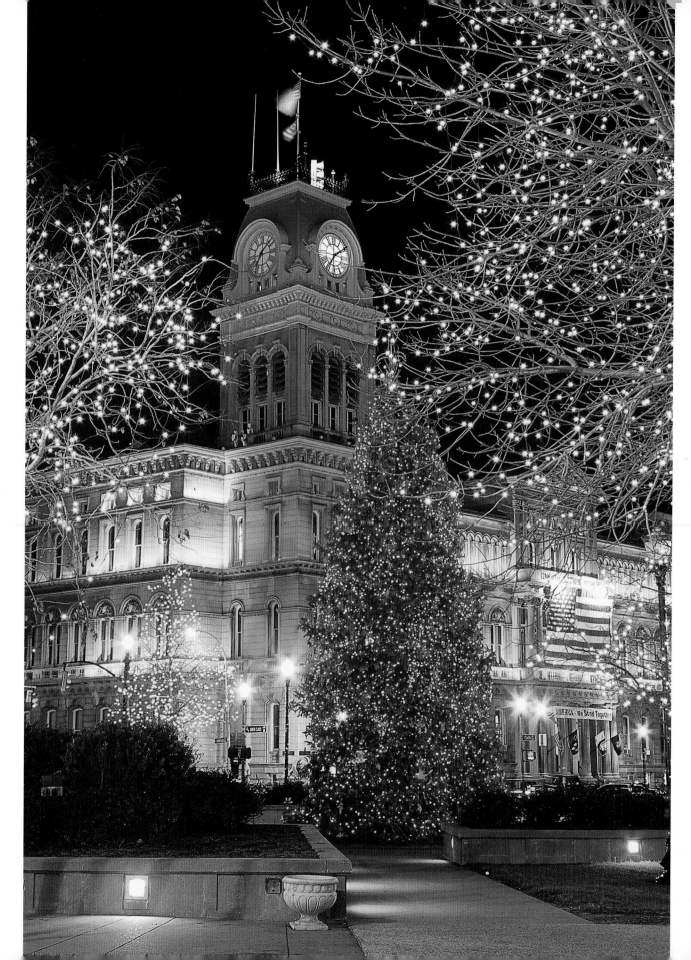

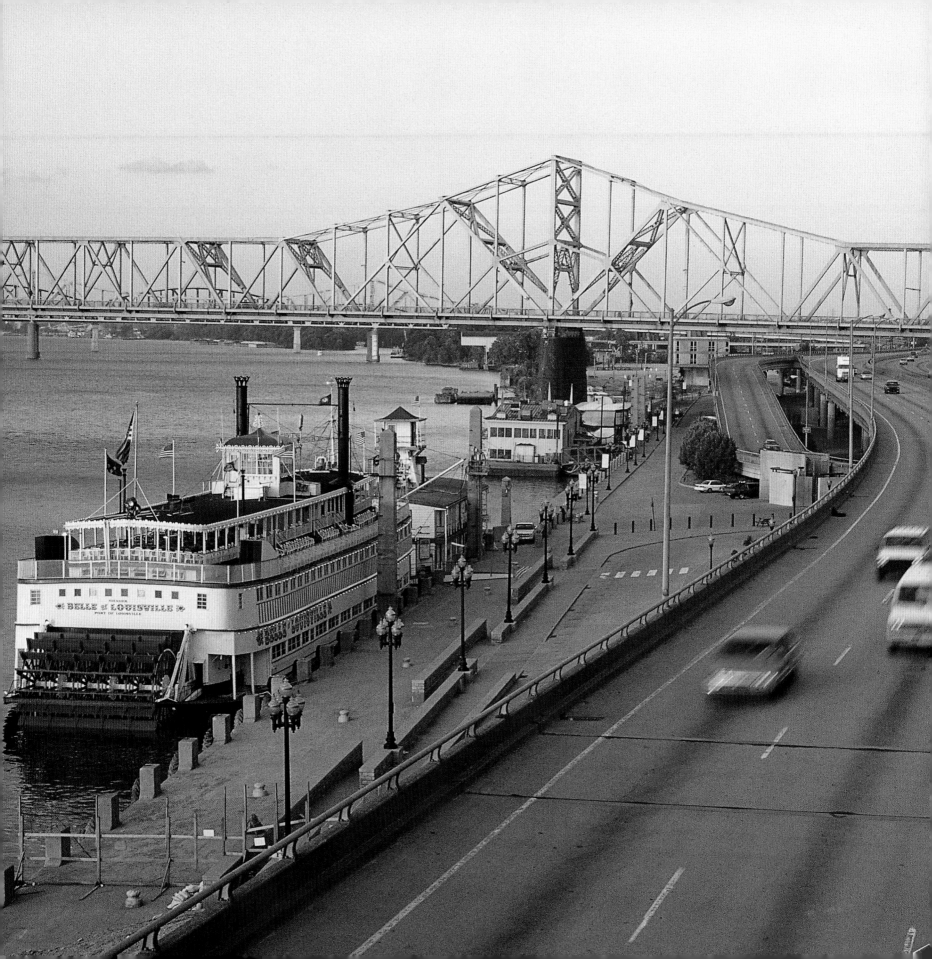

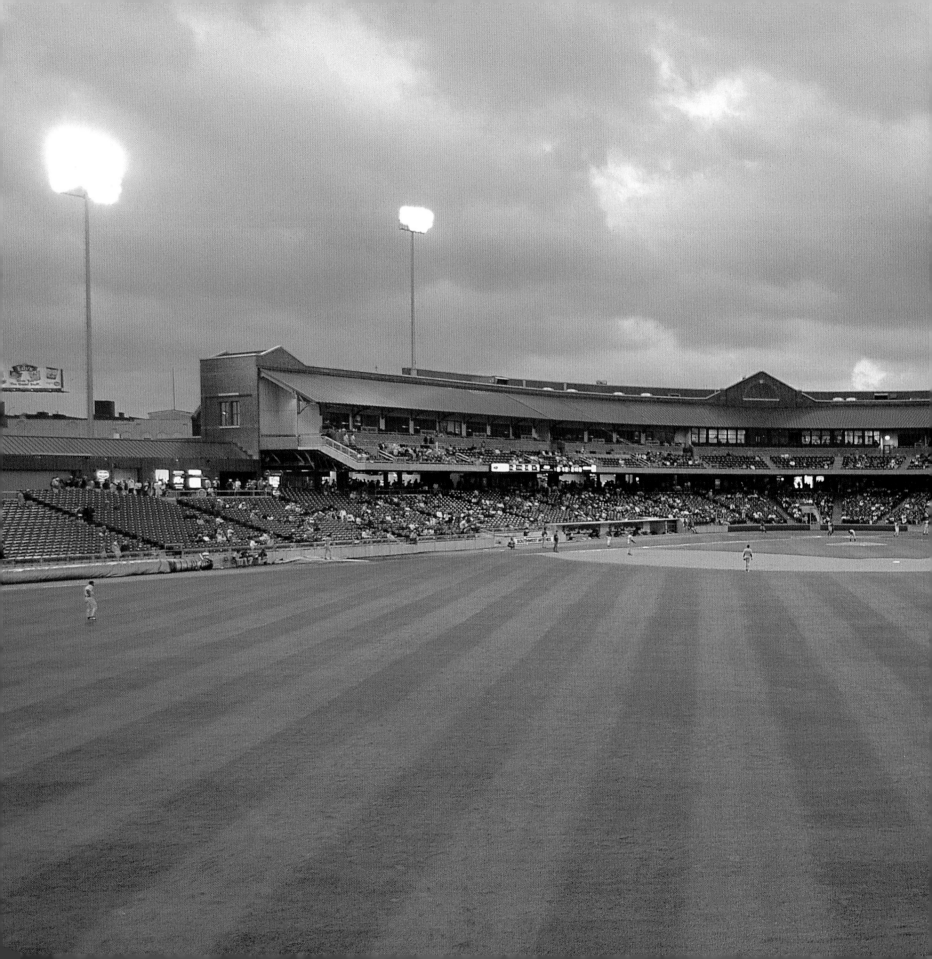

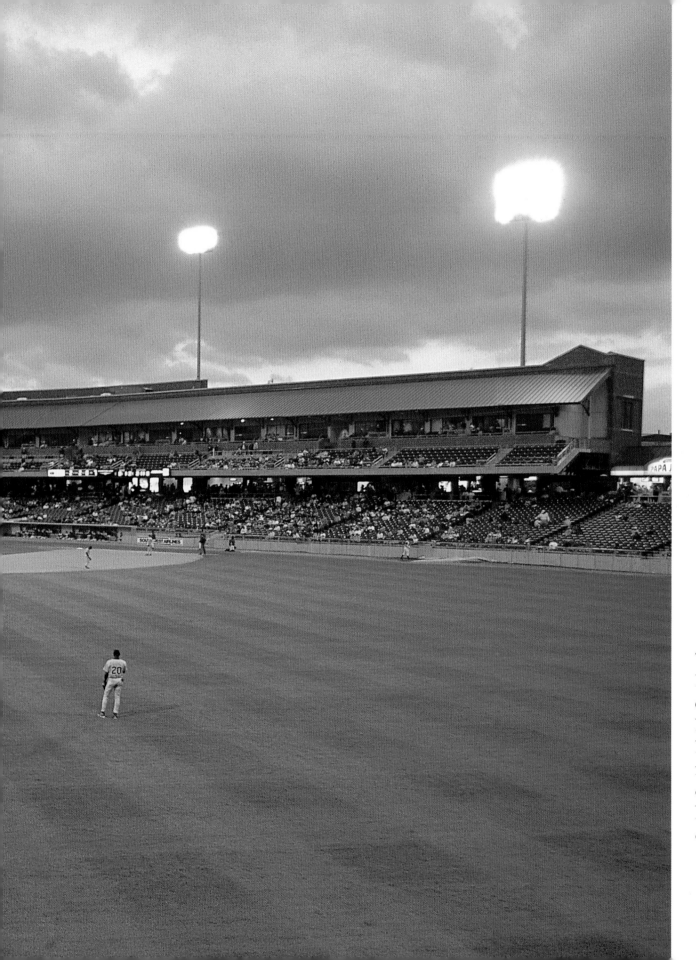

The design of Slugger Field, built in 1999, echoes classic stadiums. Home to the Minor League's Louisville Bats, it has succeeded in drawing fans and families to the city's redeveloped waterfront area.

17

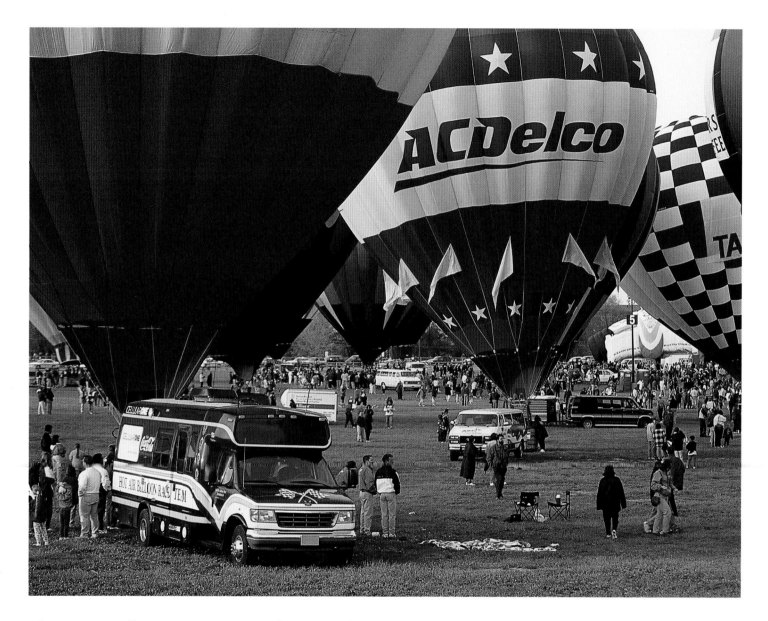

The Great Balloon Race is part of Louisville's Kentucky Derby Festival each spring. Fifty balloonists follow a pilot balloon, which marks two separate targets on the ground. Balloonists drop their bags of Kentucky bluegrass seed as close to the targets as possible without landing.

Flowing 981 miles through eight states, the Ohio River is more heavily used by industry than almost any other waterway in the nation. Tugboats such as this one with its barges of coal are a common sight from the banks of Louisville, as are shipments of oil and steel on their way downstream toward the Mississippi.

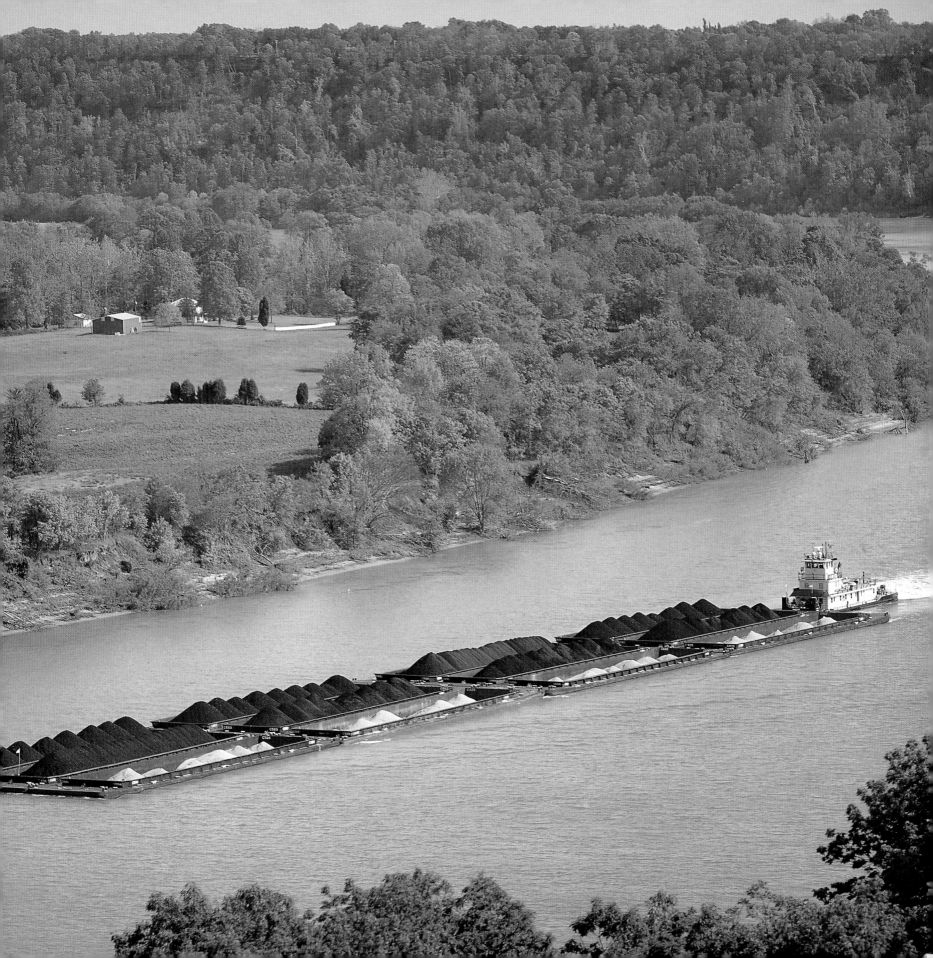

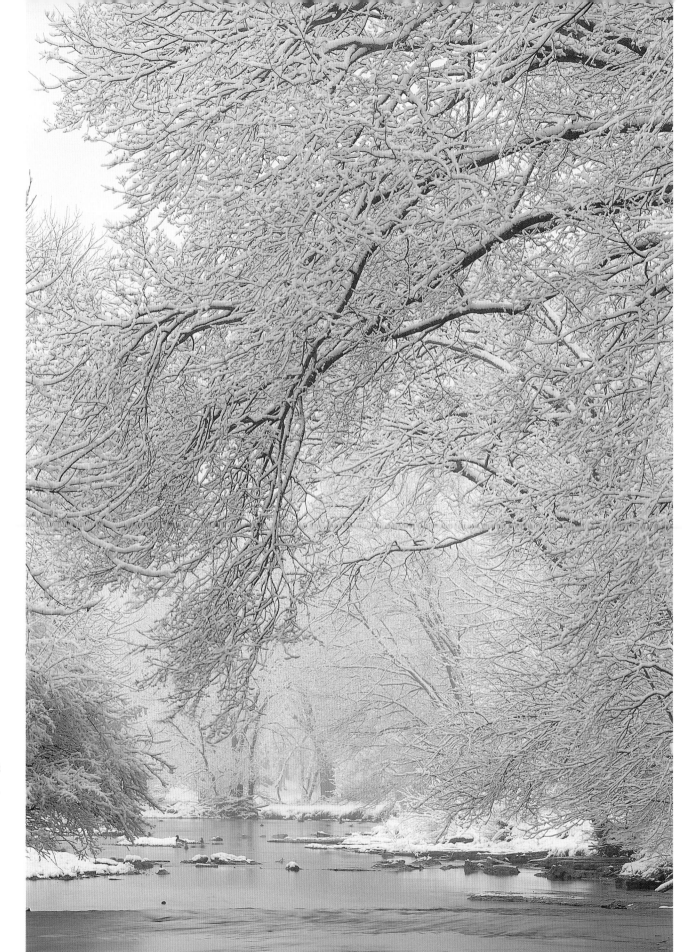

Protecting more than
180 plant and 150 bird
species, Beargrass Creek
State Nature Preserve
is a 41-acre refuge in
the center of Louisville.
Each year, thousands of
school children tour the
preserve and learn about
the unique ecosystems it
protects.

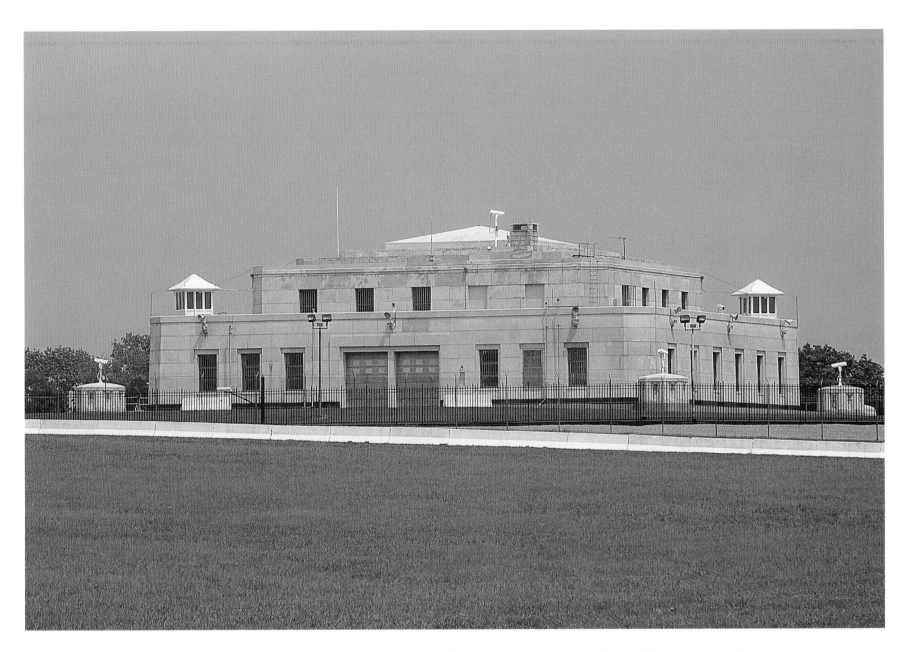

The steel and concrete vaults of Fort Knox protect the gold reserves of the United States—147.3 million ounces. While visitors aren't likely to see the inside of the repository, many tour the adjoining Patton Museum of Cavalry and Honor, an expansive look at the history of America's armed forces.

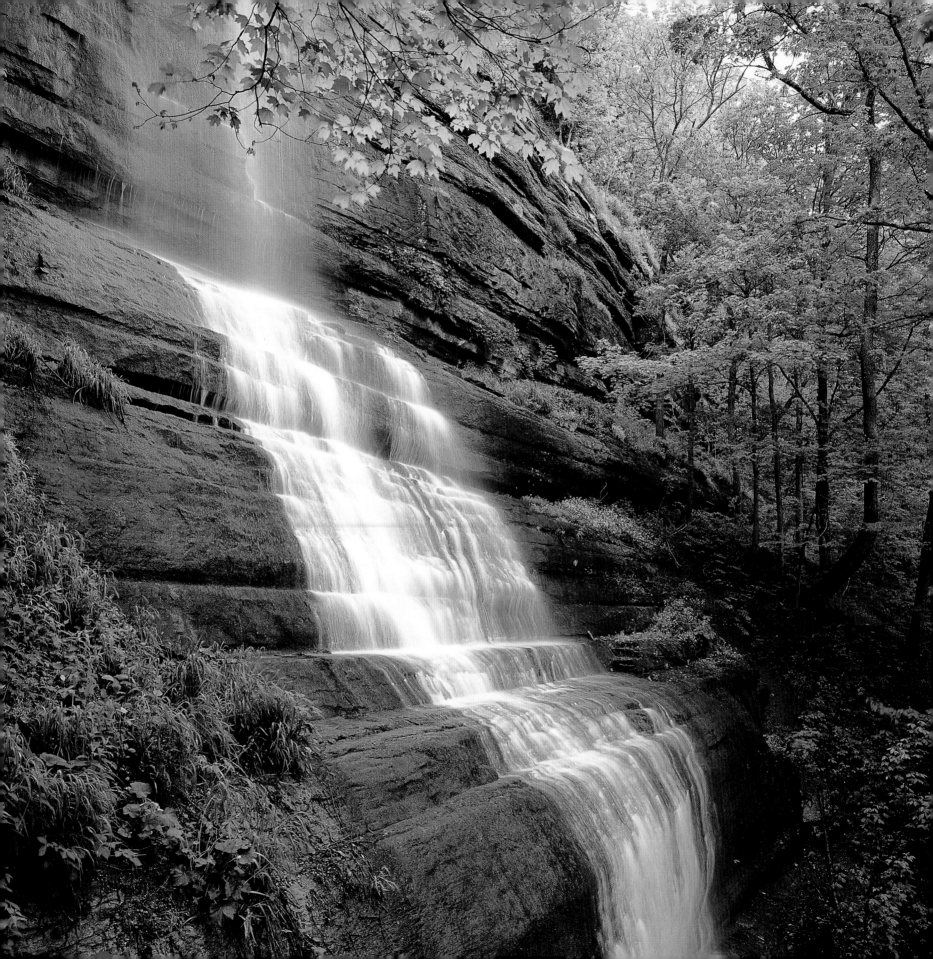

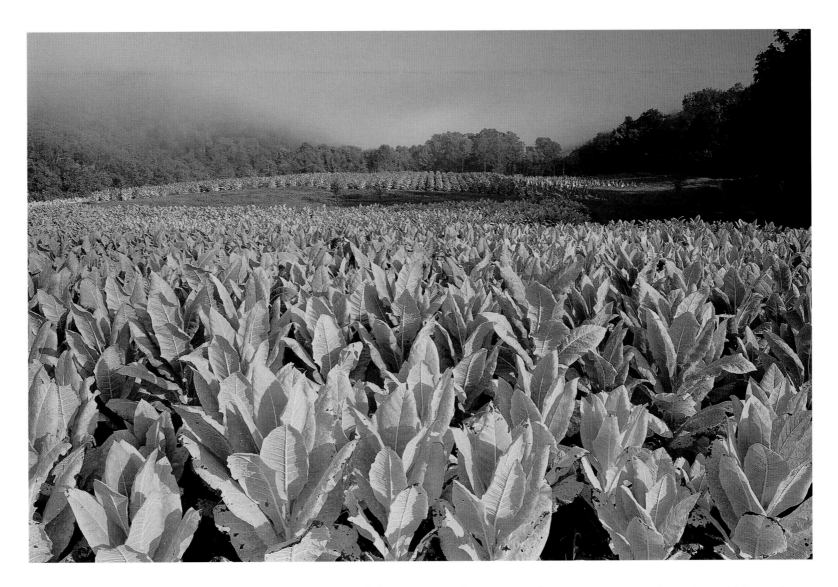

Kentucky is one of the major tobacco-producing states in America. Although the crop occupies a very small amount of the state's farmland, it accounts for a large percentage of the agricultural industry's profits—hundreds of millions of dollars each year.

More than 500,000 years ago, the Kentucky River began carving a route through the limestone of the state's Bluegrass Region. Today, the Kentucky River Palisades rise up to 400 feet above the river, offering cliffside refuges for birds, more than 400 indigenous plant species, and 36 varieties of reptiles and amphibians.

Designed by Iowa-born architect Frank Mills Andrews, Kentucky's Beaux Arts–style state capitol in Frankfort was completed in 1910. The building houses ornately carved archways, 36 immense columns of Vermont granite, marble flooring, hand-painted murals, and many sculptures.

FACING PAGE
Frank Mills Andrews' interest in historical French architecture is evident throughout the state capitol. The staircases of the Great Hall model those of the Paris Grand Opera House. The State Reception Room echoes elements of the Palace of Versailles, and the dome resembles the one over Napoleon's tomb in Paris.

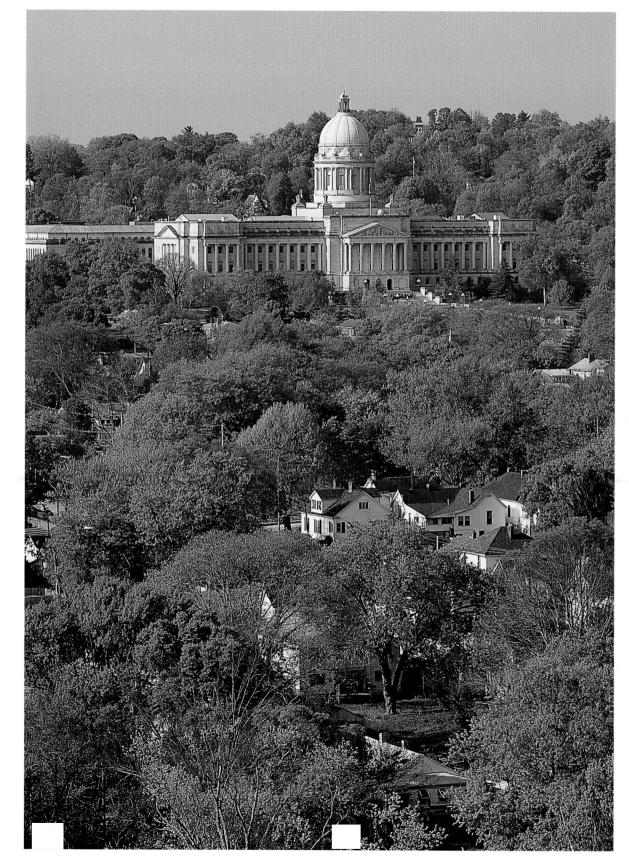

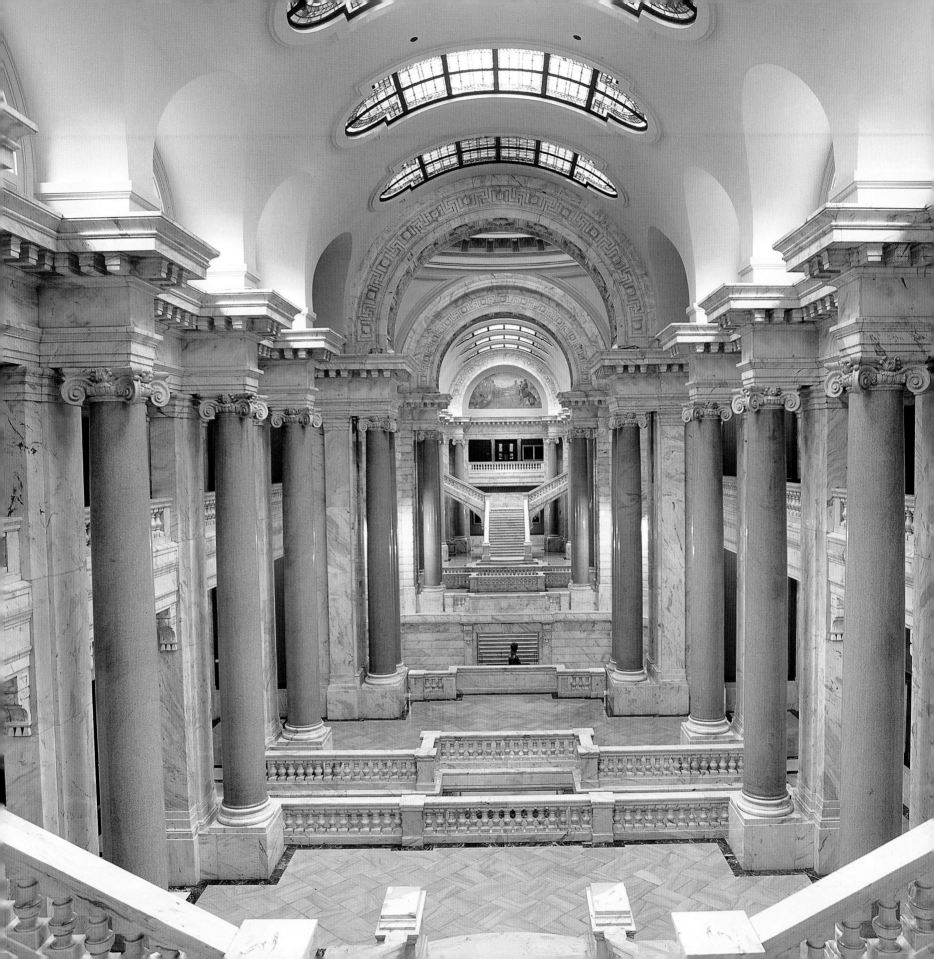

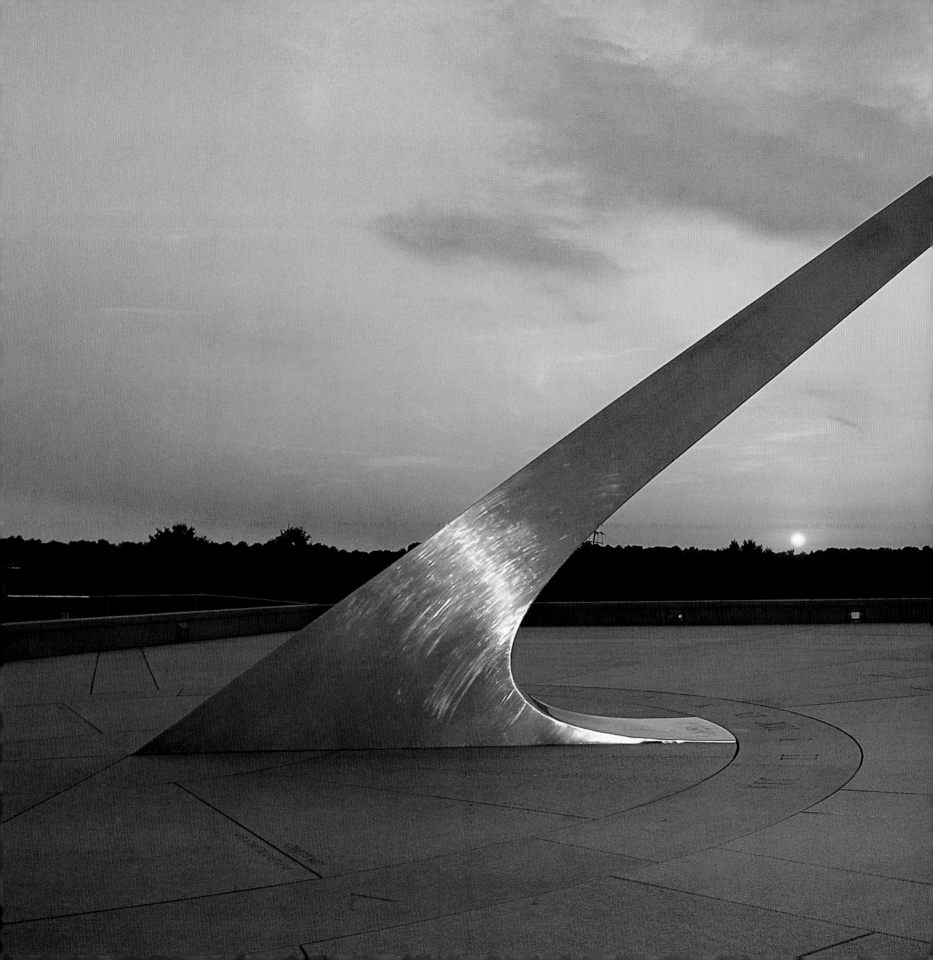

The Kentucky Vietnam Veterans Memorial in Frankfort features a granite base, engraved with the names of 1,103 state residents who lost their lives in the war. The tip of the sundial's shadow touches each name on the anniversary of the soldier's death. The memorial was designed by Helm Roberts and completed in 1988.

A canoe is the perfect way to explore the quiet waters of Elkhorn Creek in Frankfort. Paddlers discover small-mouthed bass fishing holes along the waterway, and hikers and cyclists follow creek-side trails nearby.

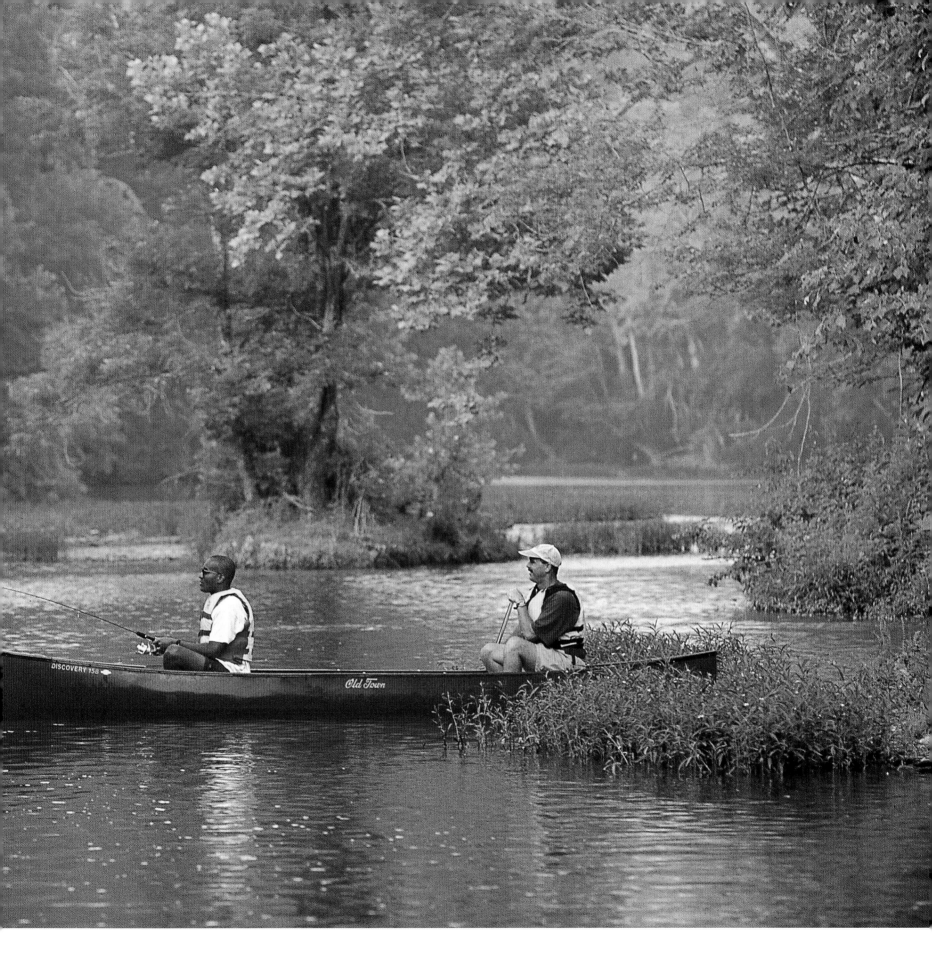

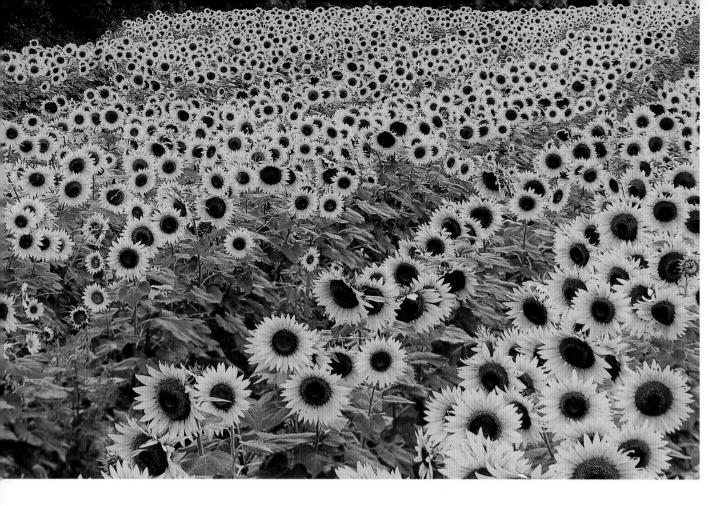

Sunflowers brighten the fields near Frankfort in late summer.
The alluvial soils left by repeated flooding and draining
make the Bluegrass Region, and the Ohio and Mississippi
river valleys, some of the most productive cropland in the
nation.

Hundreds of thousands of fans gather to watch the races
at the Kentucky Speedway in Sparta. From ARCA stock-car
racing to Indy events, the tri-oval hosts constant high-speed
action.

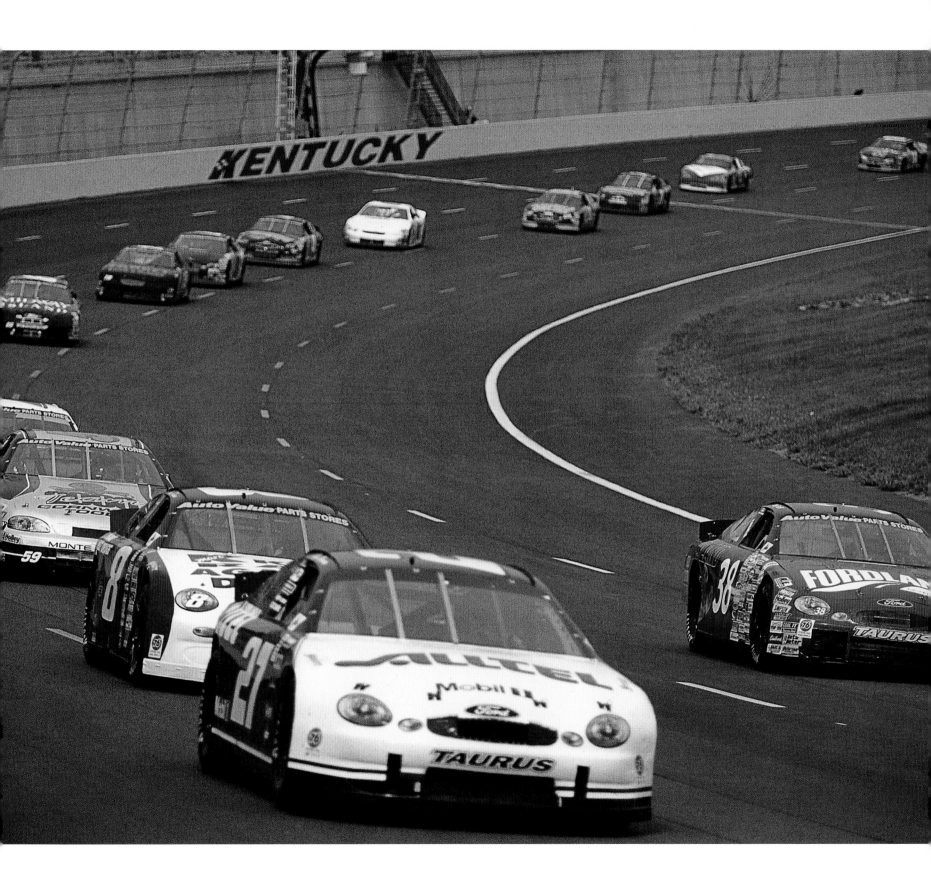

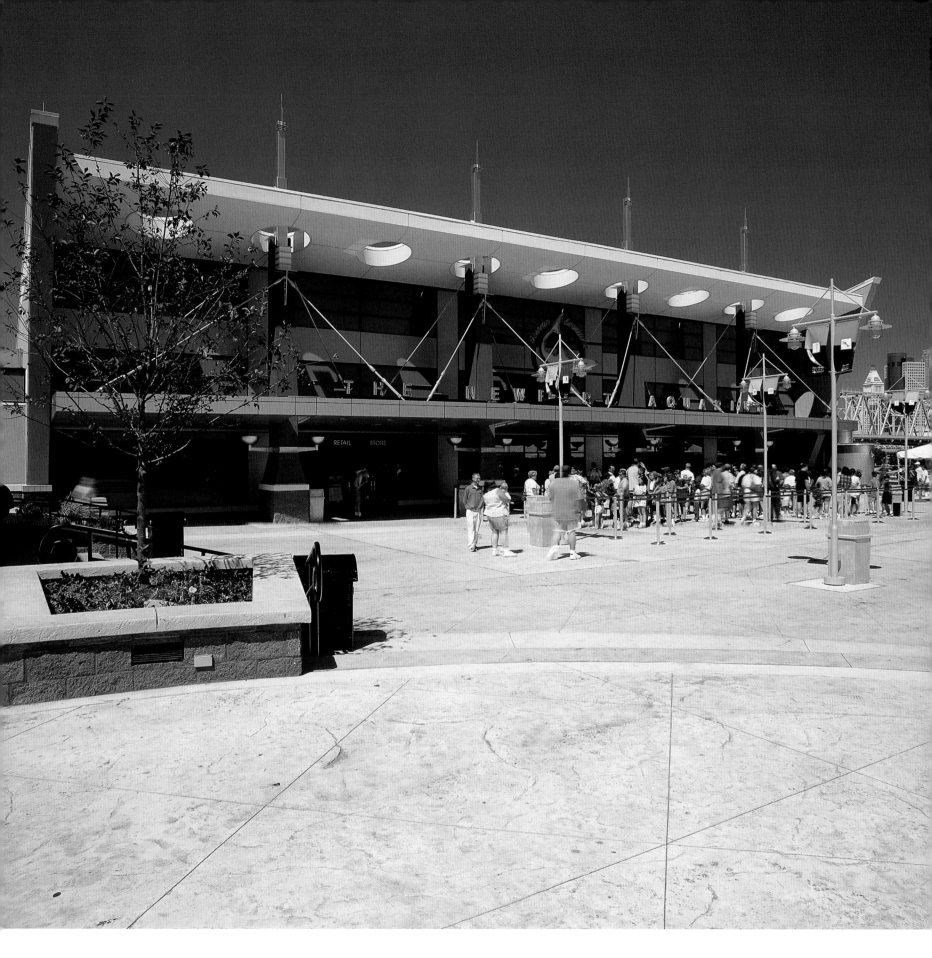

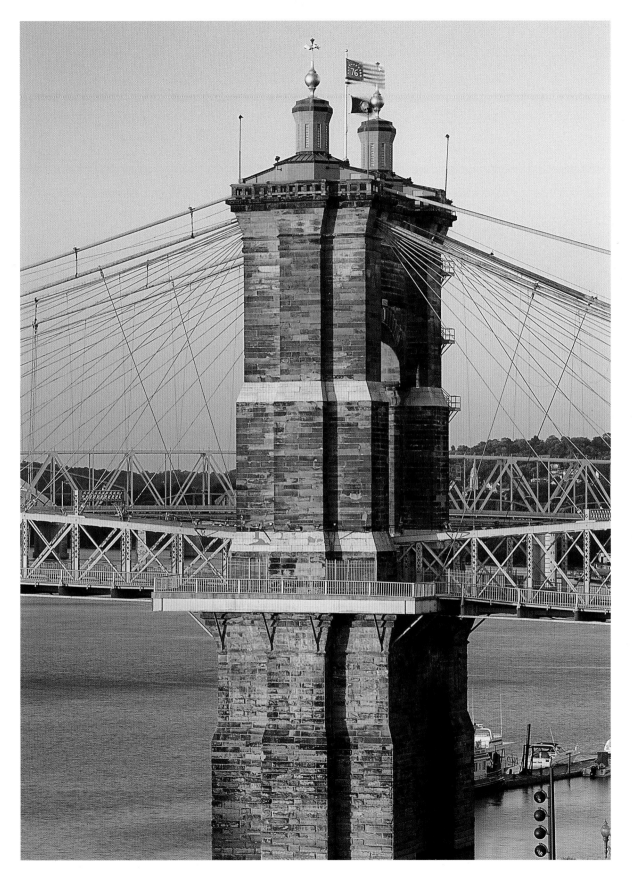

Linking Covington, Kentucky, and Cincinnati, Ohio, the John A. Roebling Suspension Bridge opened in 1866 to meet the needs of the region's booming population and growing businesses. The 1,057-foot span was the longest in the world until the Brooklyn Bridge surpassed it in 1883.

FACING PAGE
As Newport Aquarium visitors wander through hundreds of feet of transparent tunnels, they find themselves figuratively immersed in the world of 11,000 sea creatures. From the Gator Bayou to the Jellyfish Gallery, the aquarium's 60 exhibits offer an intimate tour of the Earth's waters.

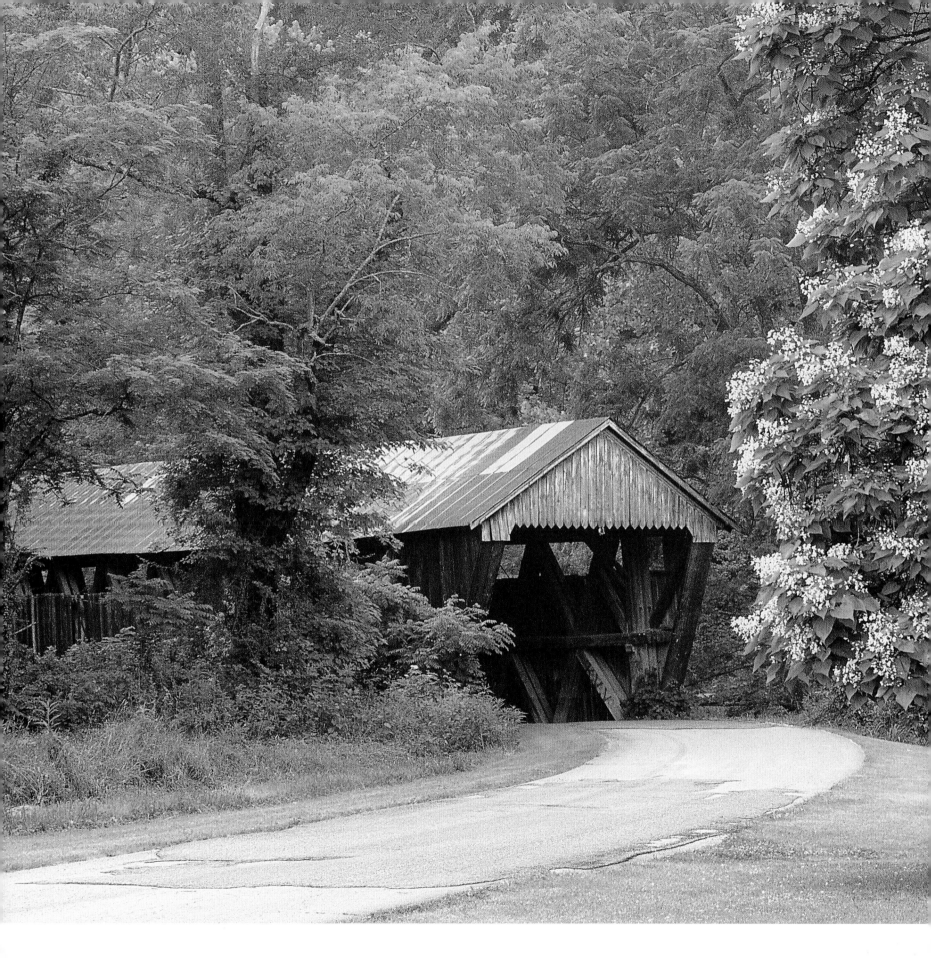

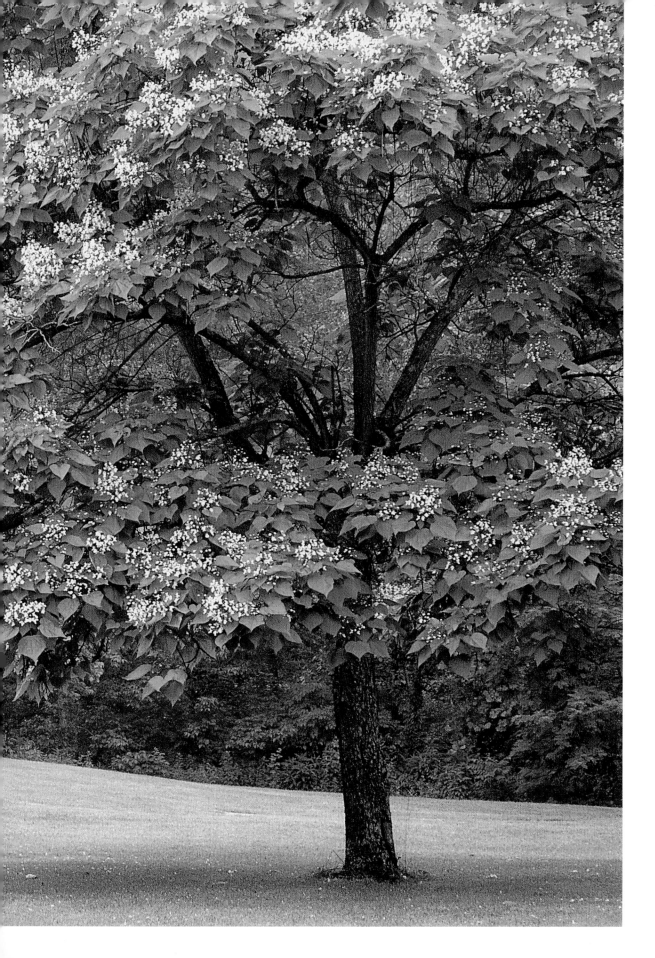

Built in 1855, this 155-foot-long covered bridge once brought customers to Bennett's Mill in Greenup County. In the 19th century, there were 800 covered bridges throughout the state. The 13 that survive are listed on the National Register of Historic Places.

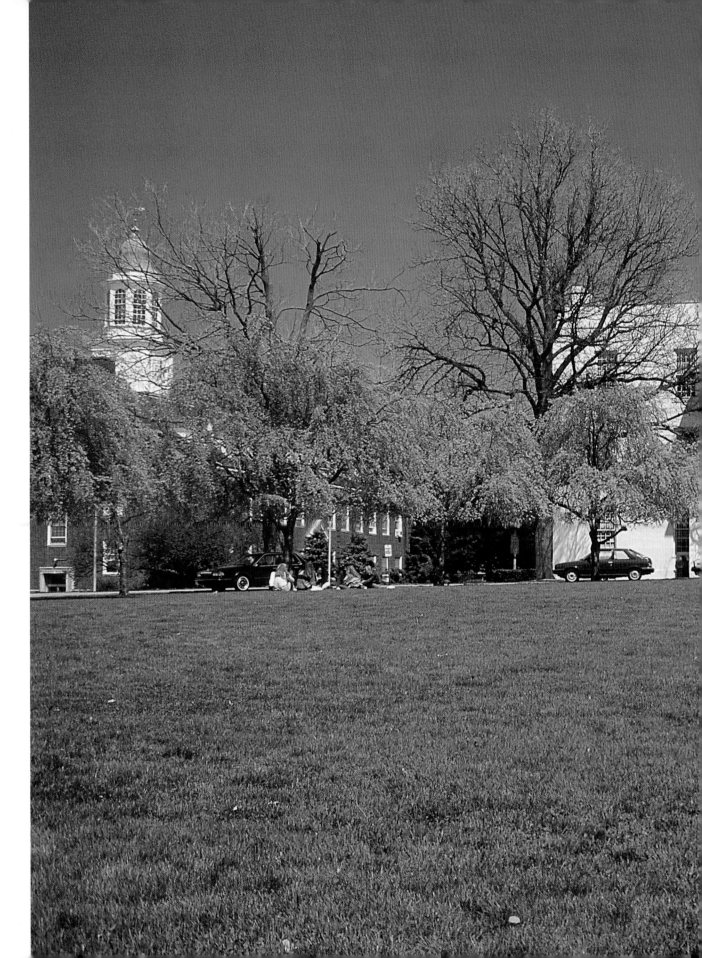

When it was founded in 1780, Transylvania University in Lexington was the sixteenth college in the nation and the first one west of the Allegheny Mountains. Alumni of the liberal arts school include 50 senators, 101 members of the House of Representatives, and 36 governors.

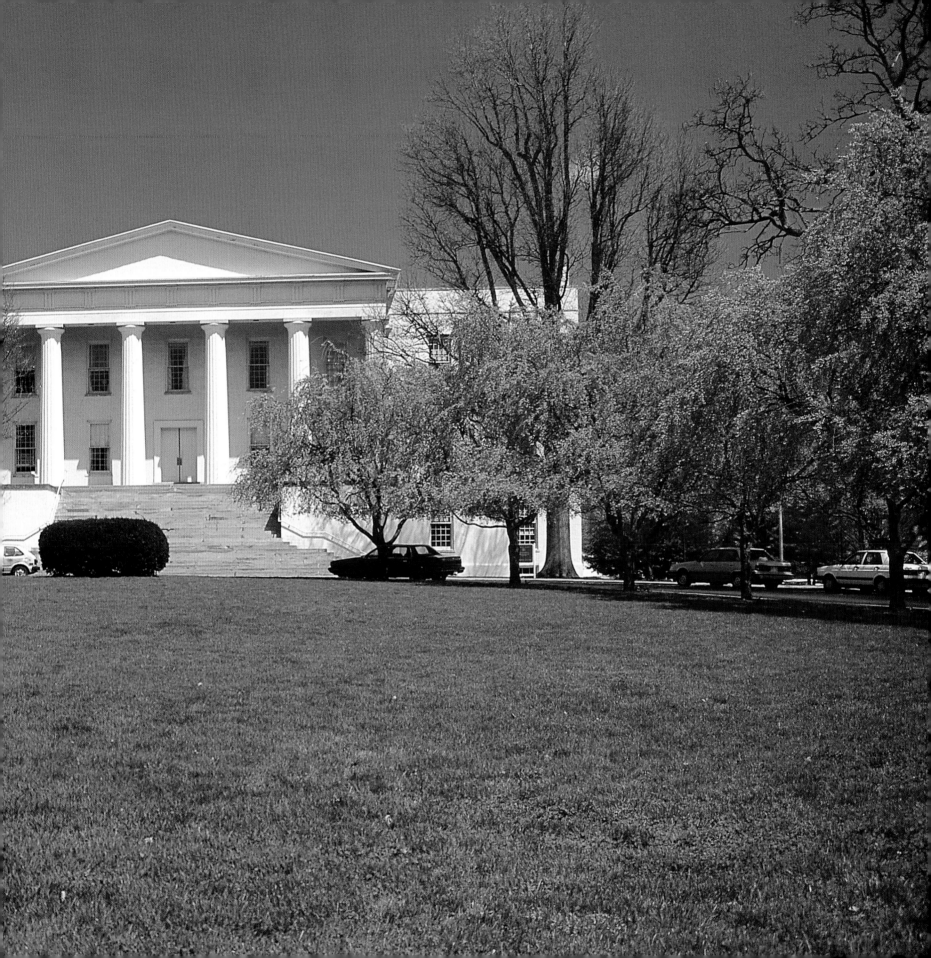

Built in the early 1800s, this stately Georgian residence was the childhood home of Mary Todd, who married Abraham Lincoln in 1842. Mary Todd Lincoln lived for 17 years after her husband's assassination and wore the black clothes of mourning the entire time. The 14-room Lexington home has been restored to reflect the times in which the Todd family lived.

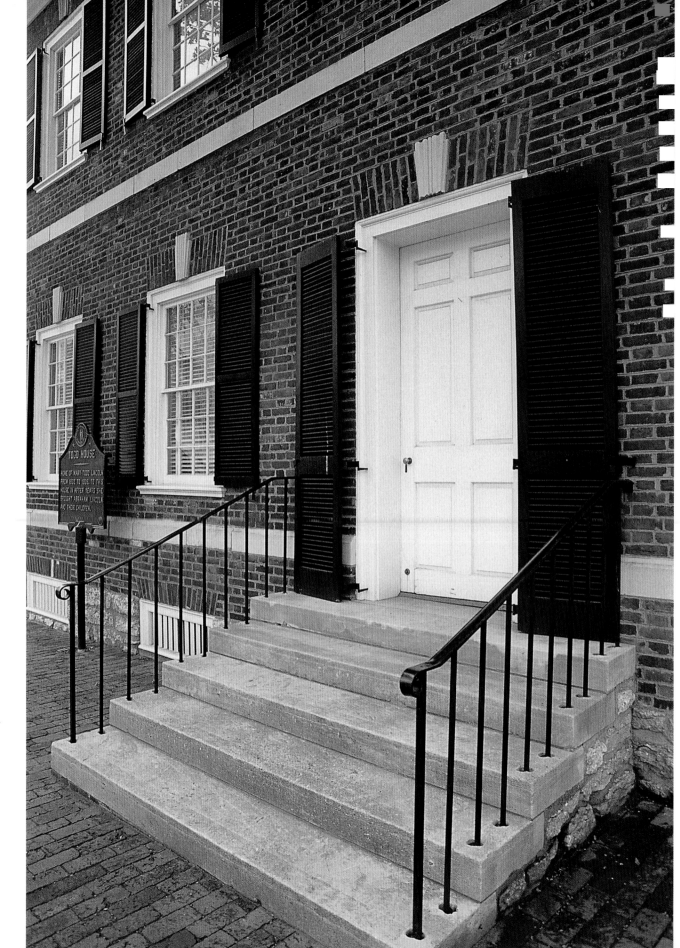

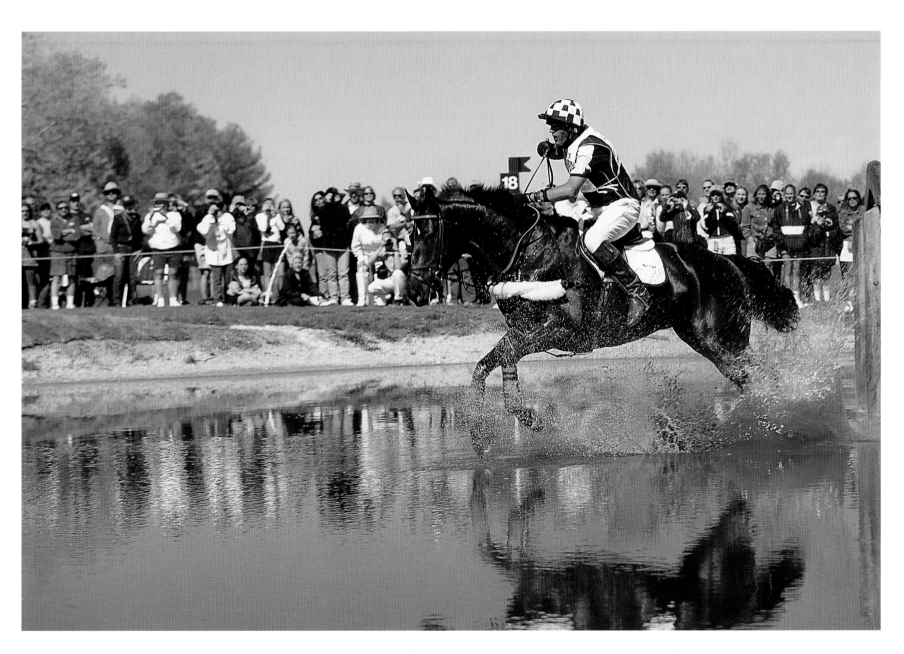

Along with hosting the world-class equestrian competition, the Kentucky Horse Park serves as a working farm. Its 1,200 acres include the American Saddlebred Museum, the Hall of Champions, a farrier's shop, and a barn housing 50 distinct breeds.

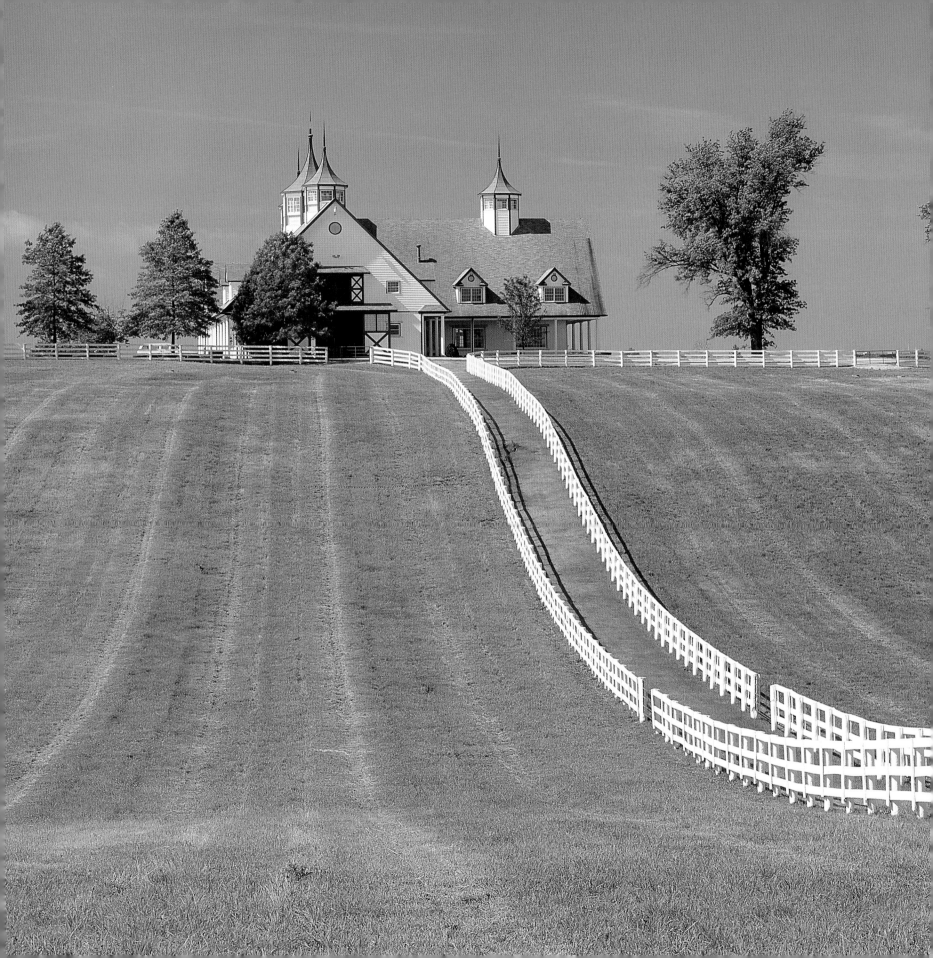

Manchester Horse Farm near Lexington is one of more than 450 in the Bluegrass Region. When Man o' War retired to pastures in this area, his groom began recording the number of visitors who arrived to see the great racehorse. By the time the horse died in 1947, more than 1.3 million people had visited.

41

Listed on the National Register of Historic Places, Mechanics Row in Maysville is a combination of Gothic–, Federal–, and Greek Revival–style row houses. As well as its treasure trove of historical shops and homes, Maysville claims an important history as a stop on the Underground Railroad, ushering slaves north toward freedom.

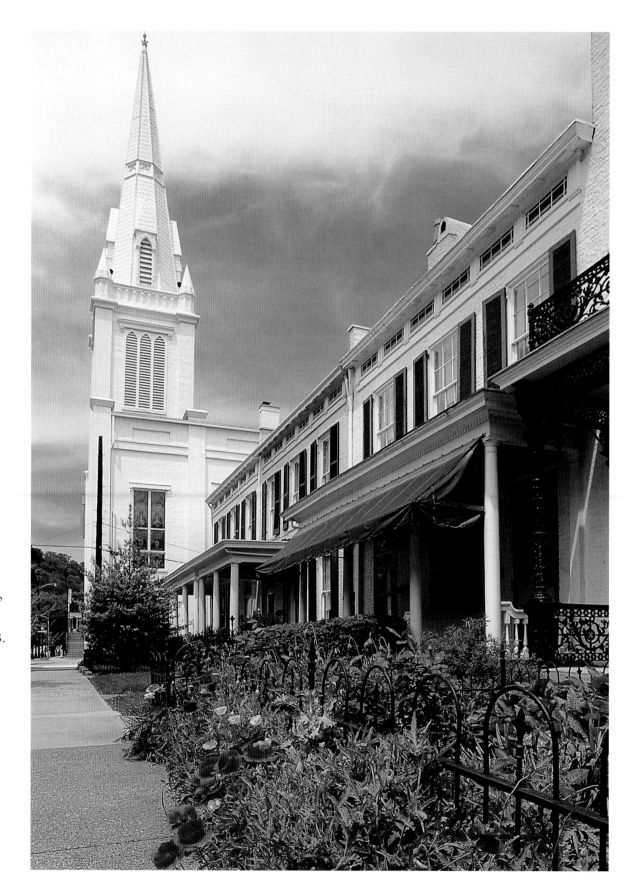

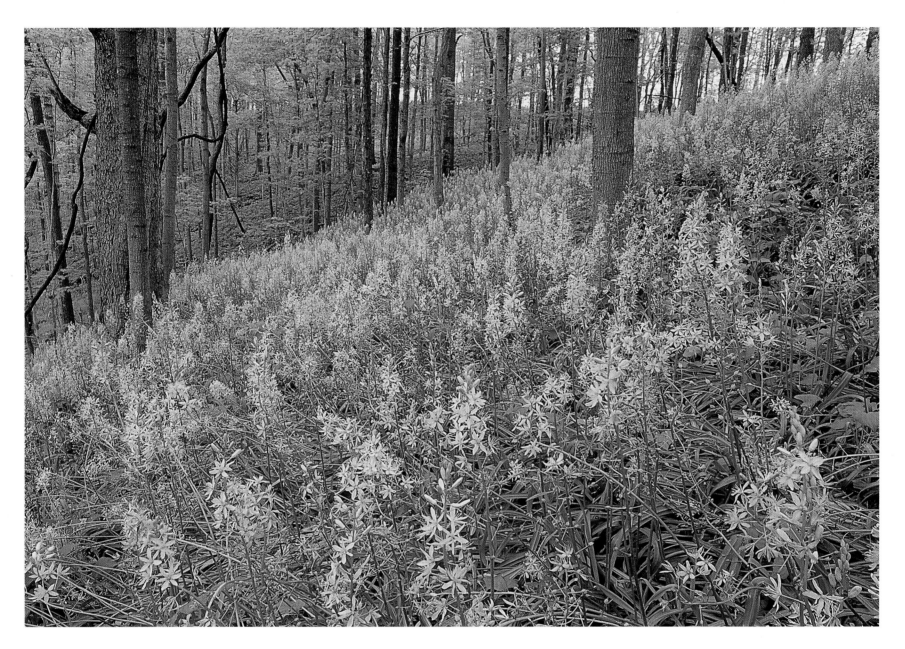

Wild hyacinth carpets a hillside in Raven Run Nature Sanctuary in Lexington. The 374-acre preserve encompasses eight miles of walking paths as well as a nature center and a bird-watching blind. From rare native plants to rock fences built by early pioneers, the park provides both relaxation and education.

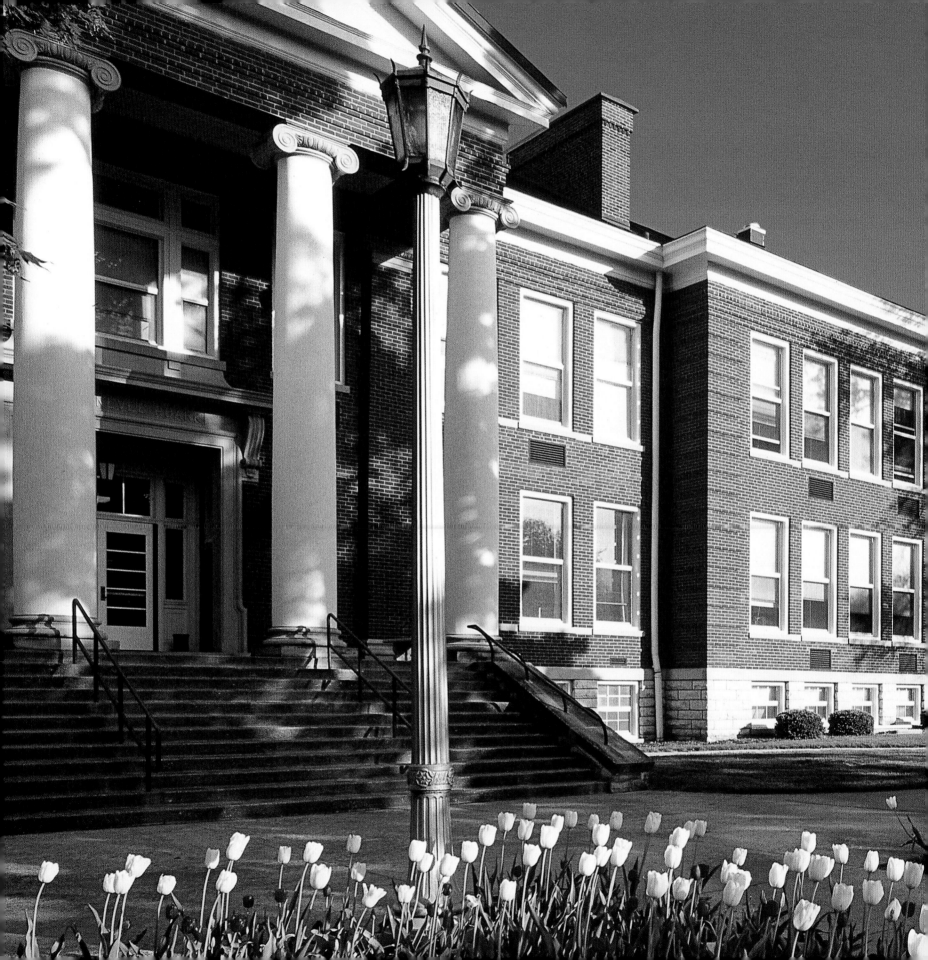

The Ruric Neval Roark Building at Eastern Kentucky University in Richmond was built in 1909 and is named for the school's first president.

OVERLEAF
Large snowfalls such as the one that blankets this farm near Winchester are not uncommon in Kentucky, yet winter weather is usually mild. Afternoon temperatures often rise above the freezing point, melting the result of most winter storms after a few days.

45

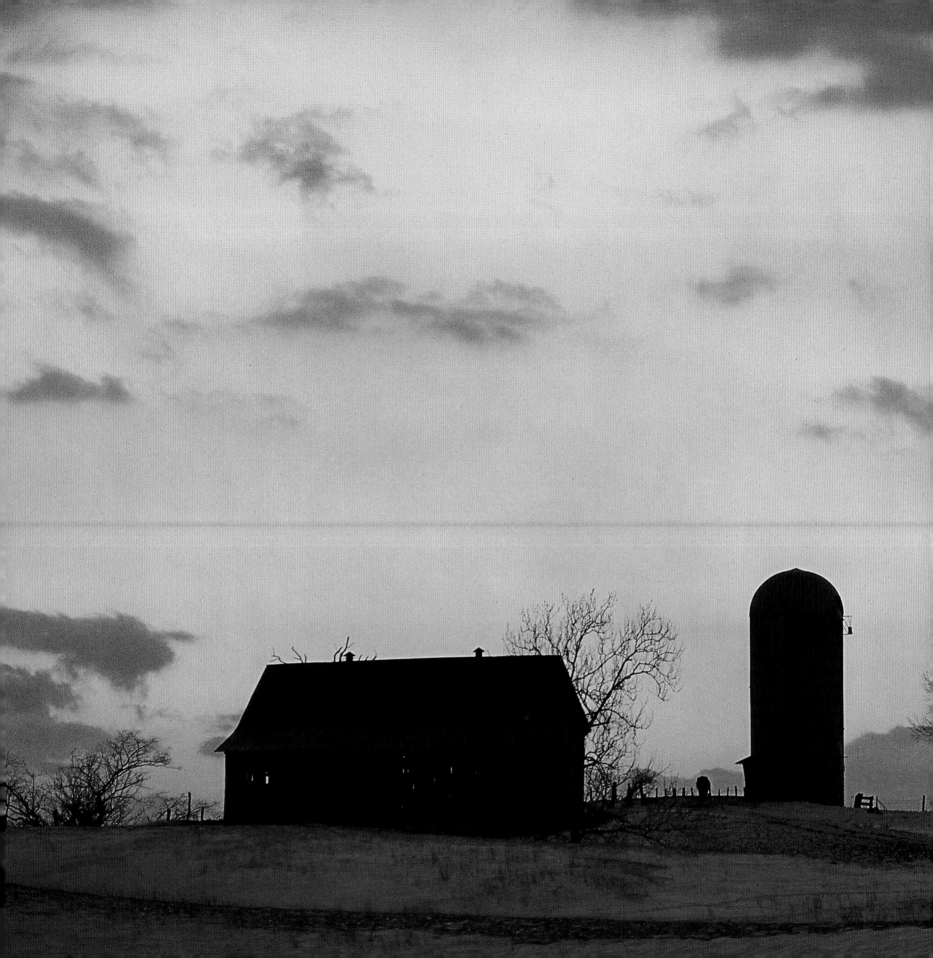

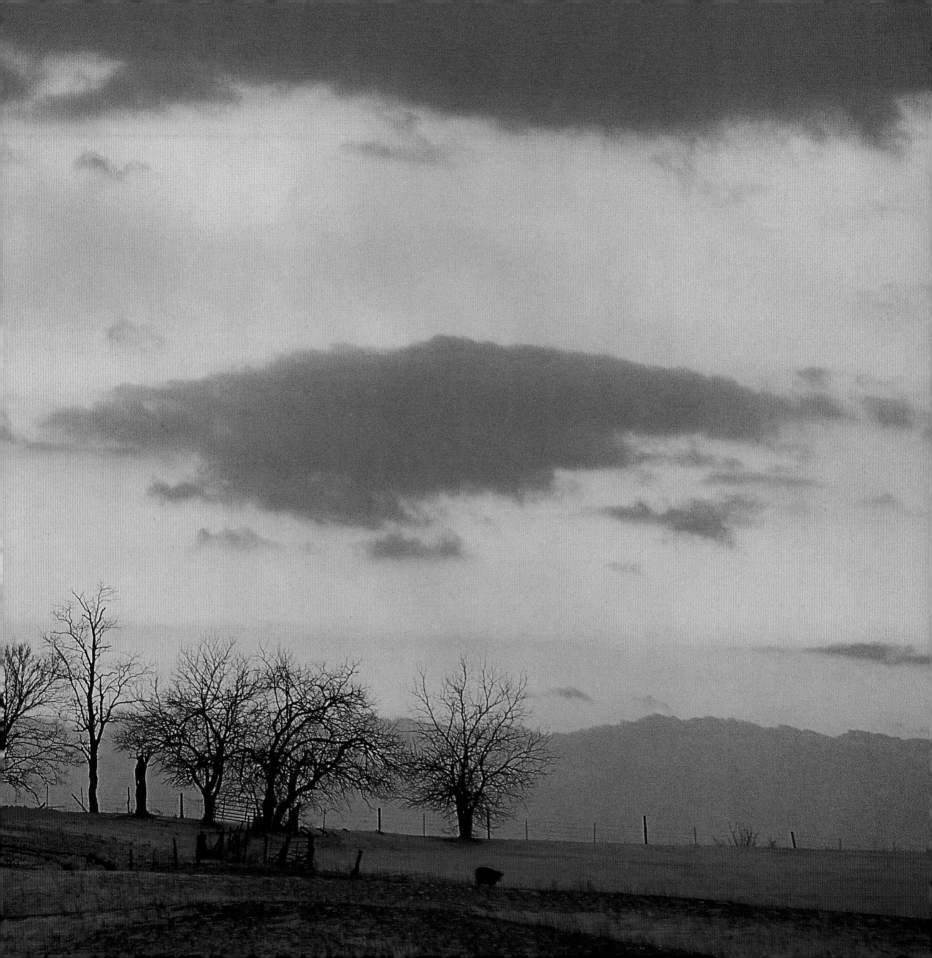

Bad Branch State Nature Reserve in Letcher County shelters a distinct ecosystem. Cooled by mountain streams and canyon shade, the plants that thrive here are usually found only farther north or at higher elevations. Early Kentucky navigators named the stream Bad Branch to warn people away from the waterway's treacherous falls and rapids.

FACING PAGE
The Kentucky-Virginia border is marked by a 5-mile-long chasm that reaches depths of 1,600 feet. Protected by Breaks Interstate Park, the canyon was carved by the Russell Fork River and is the largest east of the Mississippi. Twelve miles of hiking trails give visitors a close-up view of the region's unique geography.

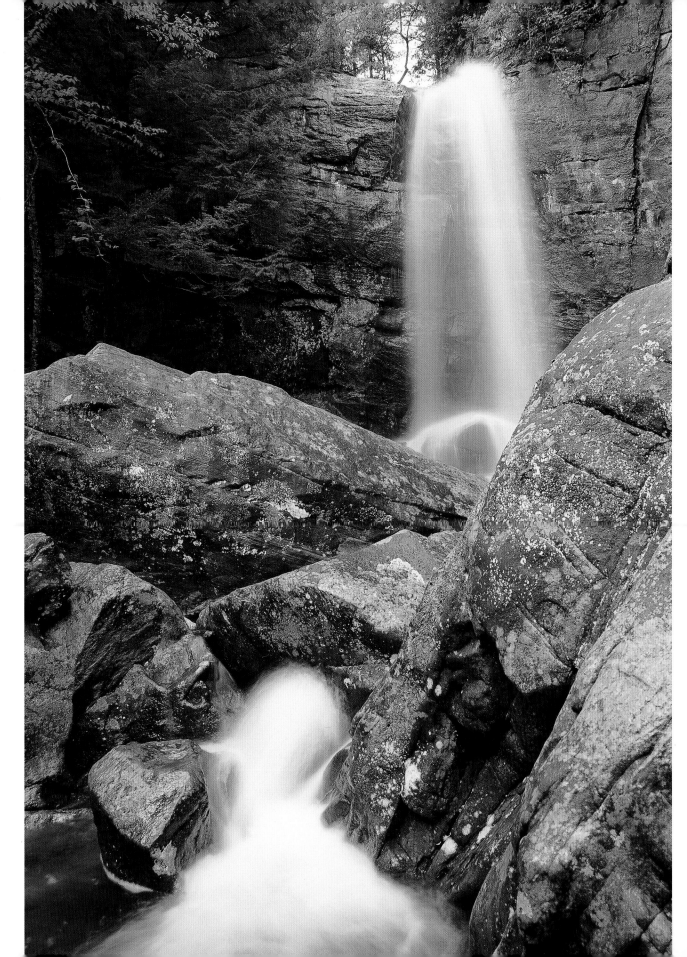

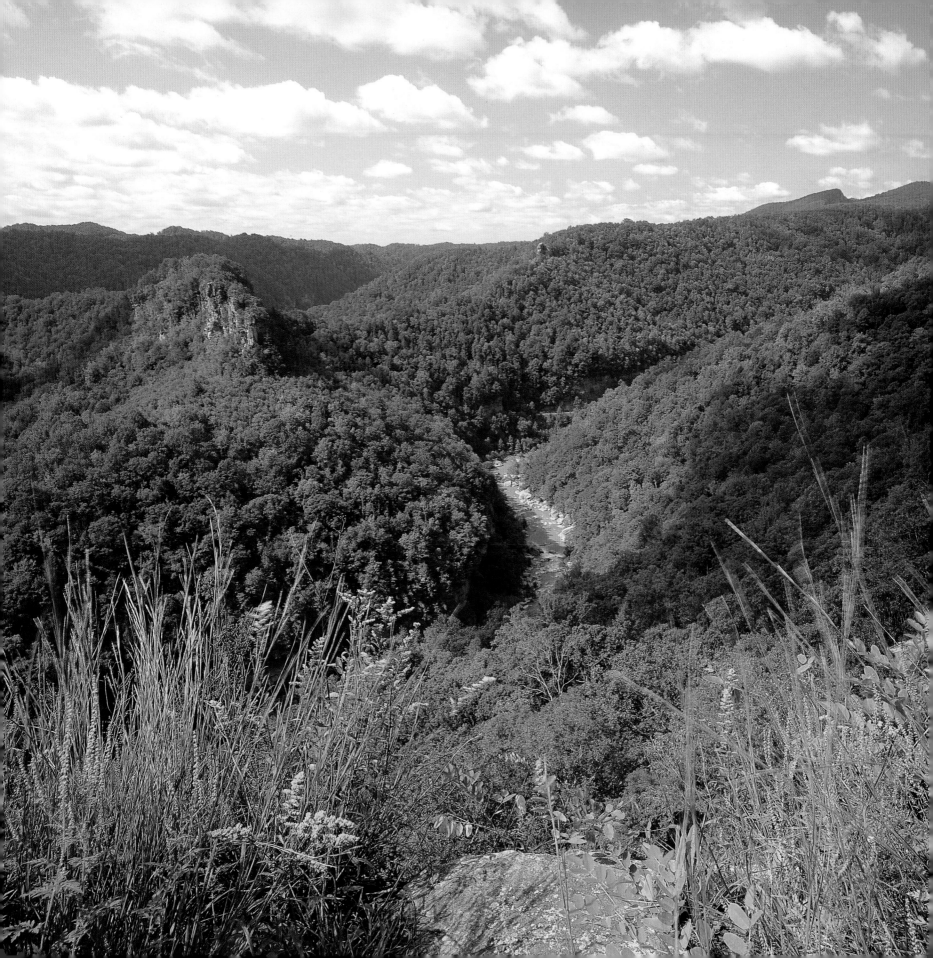

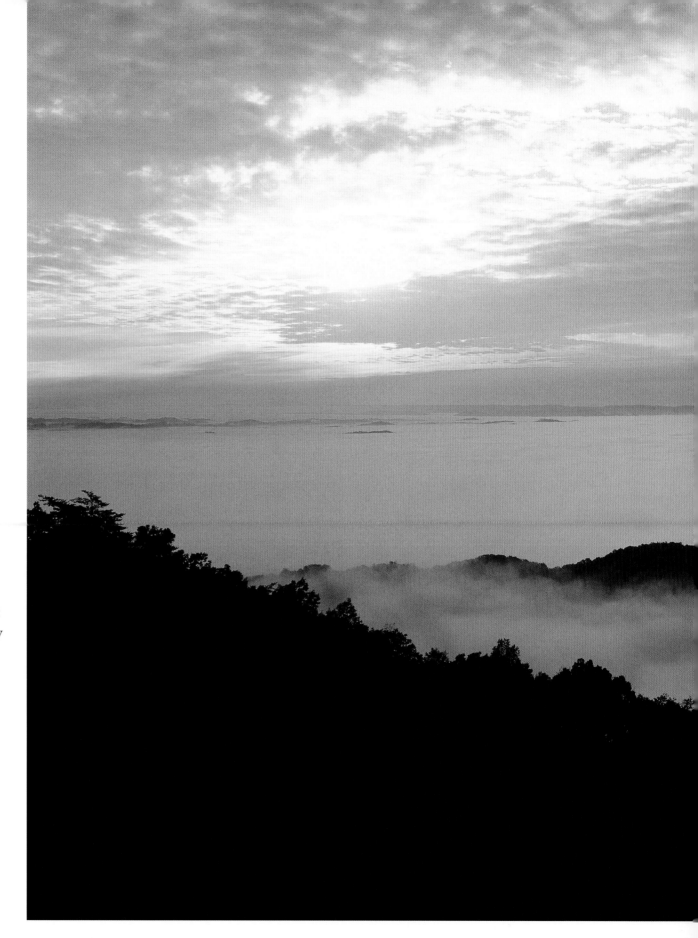

Cumberland Gap National Historic Park protects the place where wind and water gradually carved a break in the Appalachian Mountains. This gap served as a gateway to the west for early settlers—more than 200,000 people traveled through the region between 1775 and 1810.

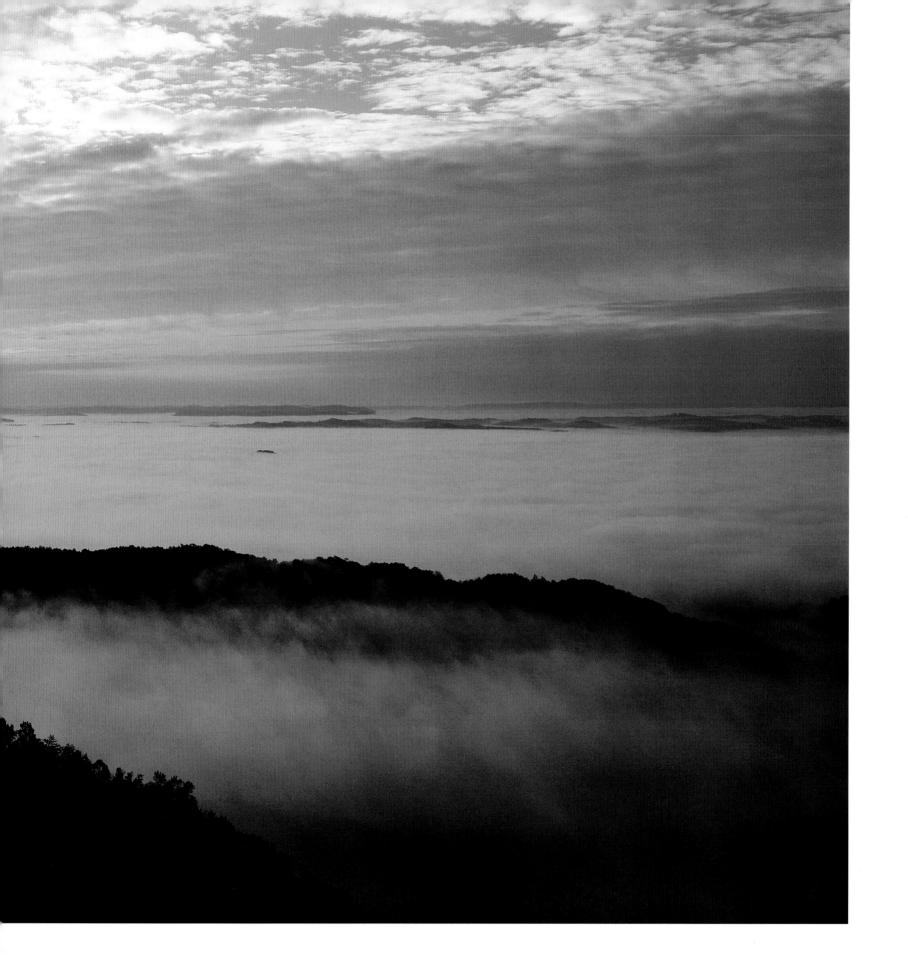

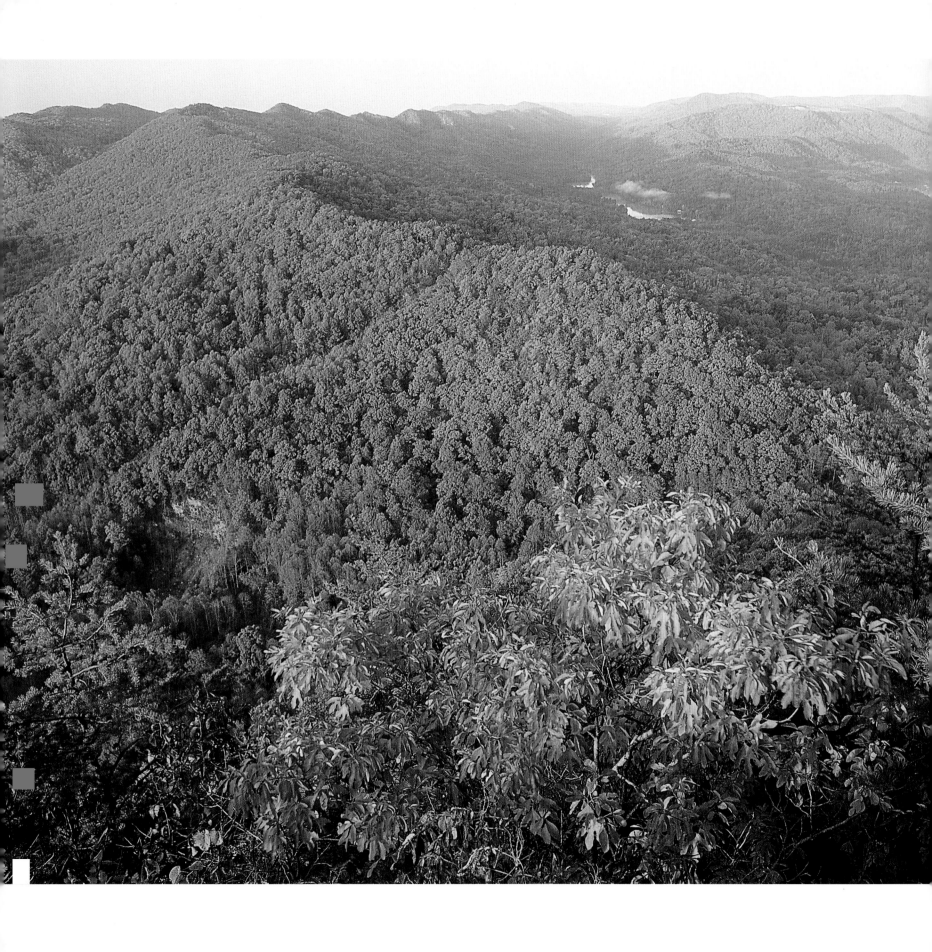

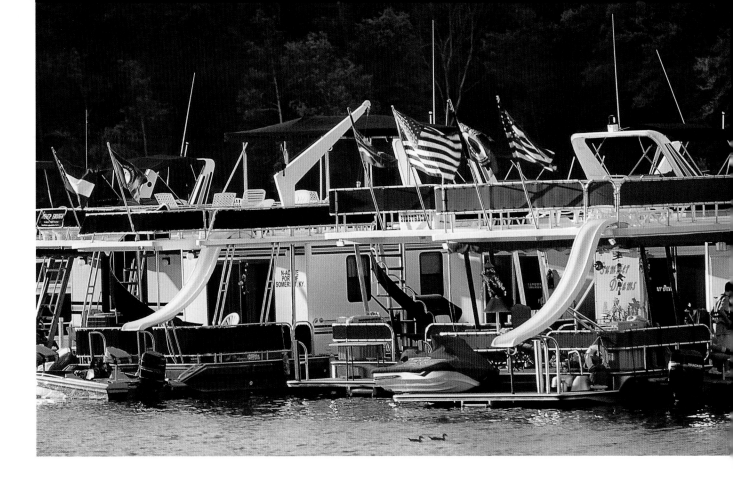

Houseboating on Lake Cumberland is a favorite family vacation in Kentucky. The boats allow access to the lake's 1,255 miles of pristine shoreline, with swimming, fishing, and watersports along the way.

With more than 20,000 acres and 50 miles of hiking trails, Cumberland Gap National Historic Park draws thousands of nature lovers each year. From Pinnacle Overlook, 2,440 feet above sea level, sightseers gain a panoramic view of Kentucky, Tennessee, and Virginia.

Created in 1924, Pine Mountain State Resort Park was Kentucky's first state preserve. The mountain slopes of the state's southeastern corner offer hiking, swimming, picnicking, and camping.

FACING PAGE
The tiny town of Pineville was settled in 1781 and became the seat of Bell County in 1867. The community serves as a gateway to Pine Mountain State Resort Park and the surrounding recreational activities.

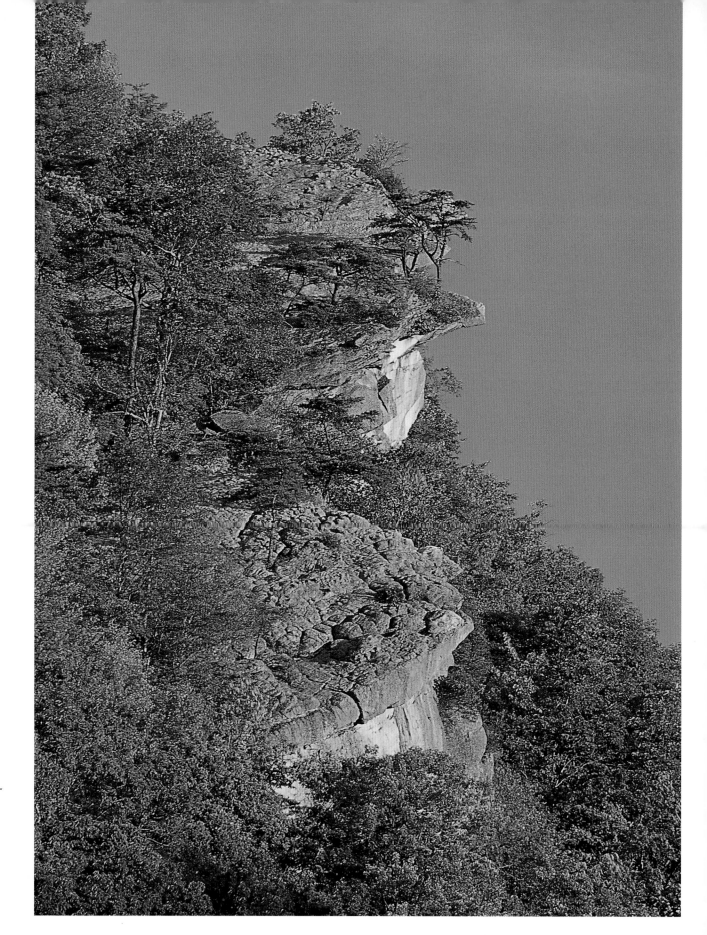

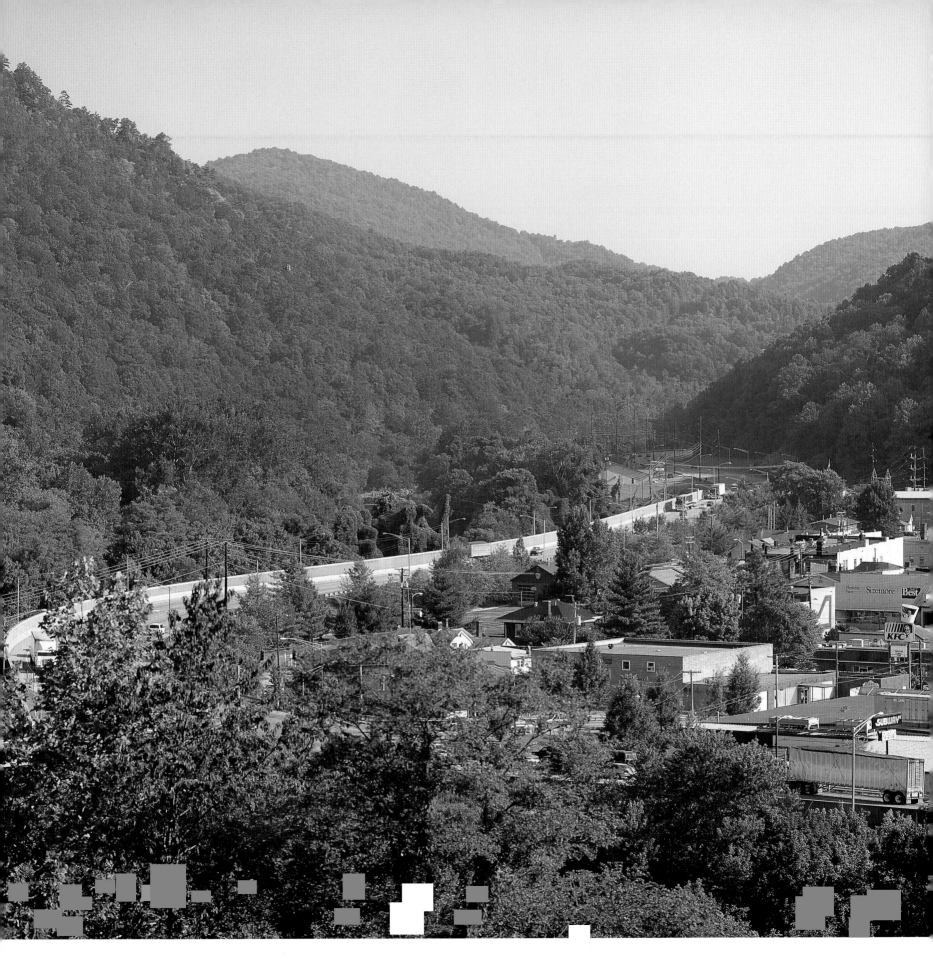

Encircled by mountains, Wasioto Winds Golf Course in Pineville winds its way among lakes, creeks, and wetlands, offering a challenging 18 holes. The course was designed by Dr. Michael Hurdzan, one of America's best-known course architects.

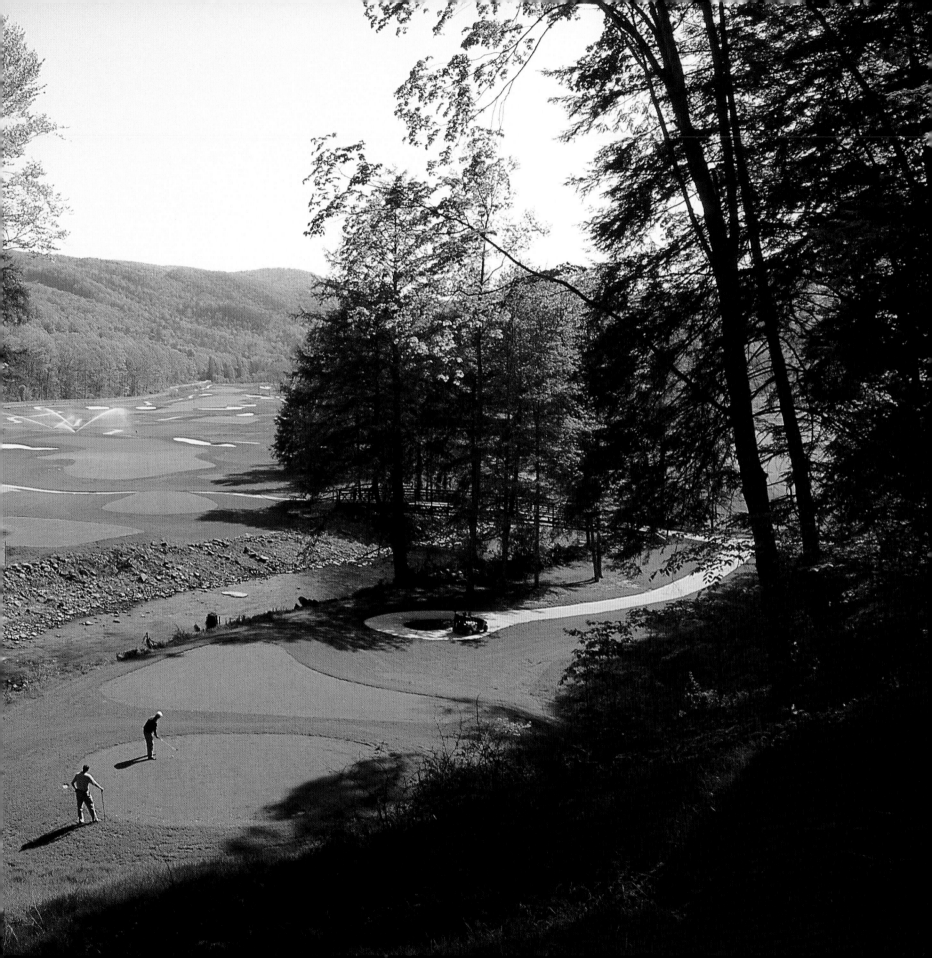

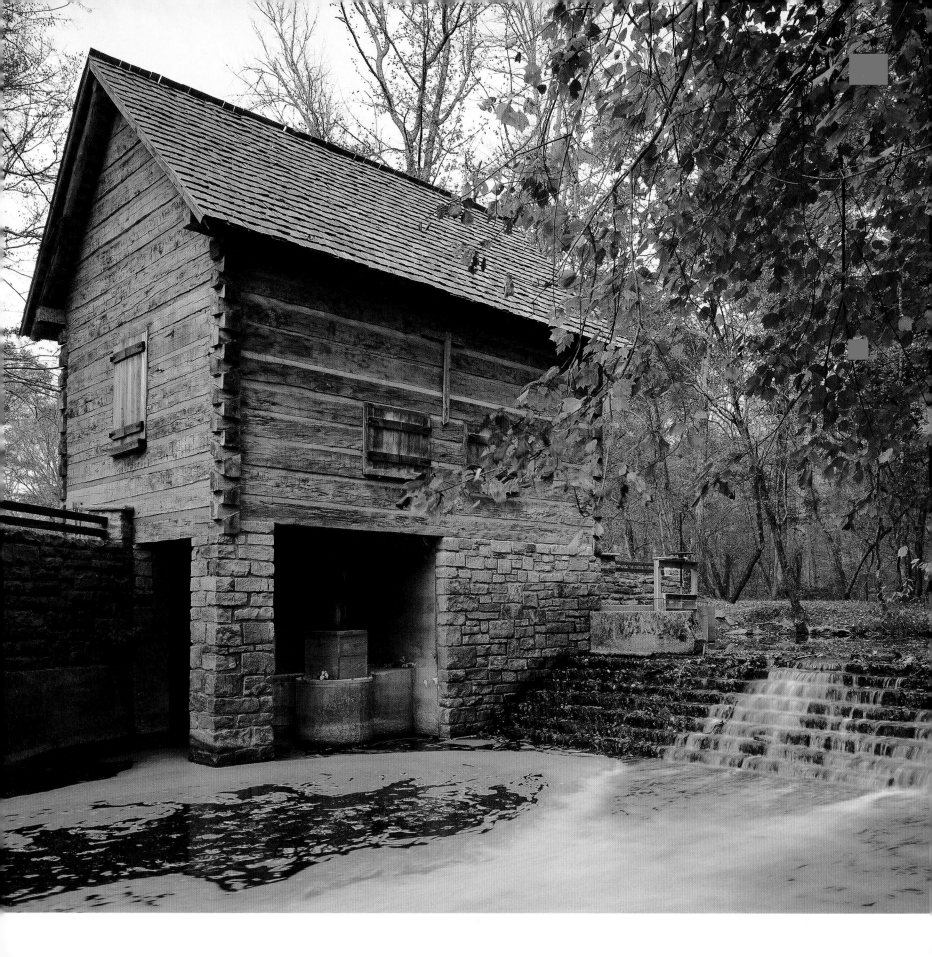

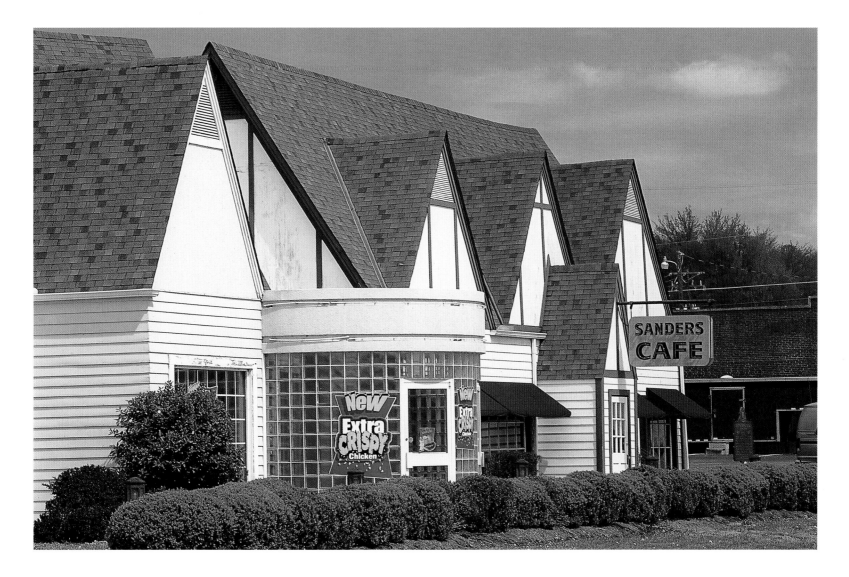

Colonel Harlan Sanders' first restaurant stands in Corbin as a memorial to the man who founded Kentucky Fried Chicken. In the 1960s, after operating his own successful restaurant, the Colonel traveled the continent with his wife, Claudia, cooking sample chickens with his eleven herbs and spices. He established more than 600 franchises before selling the company for $2 million.

Lying along the route by which early English colonists traveled west, Levi Jackson Wilderness Road State Park is named for Laurel County's first judge. The 800-acre preserve showcases several historic sites, including McHargue's Mill, with its millstone and many other original features intact.

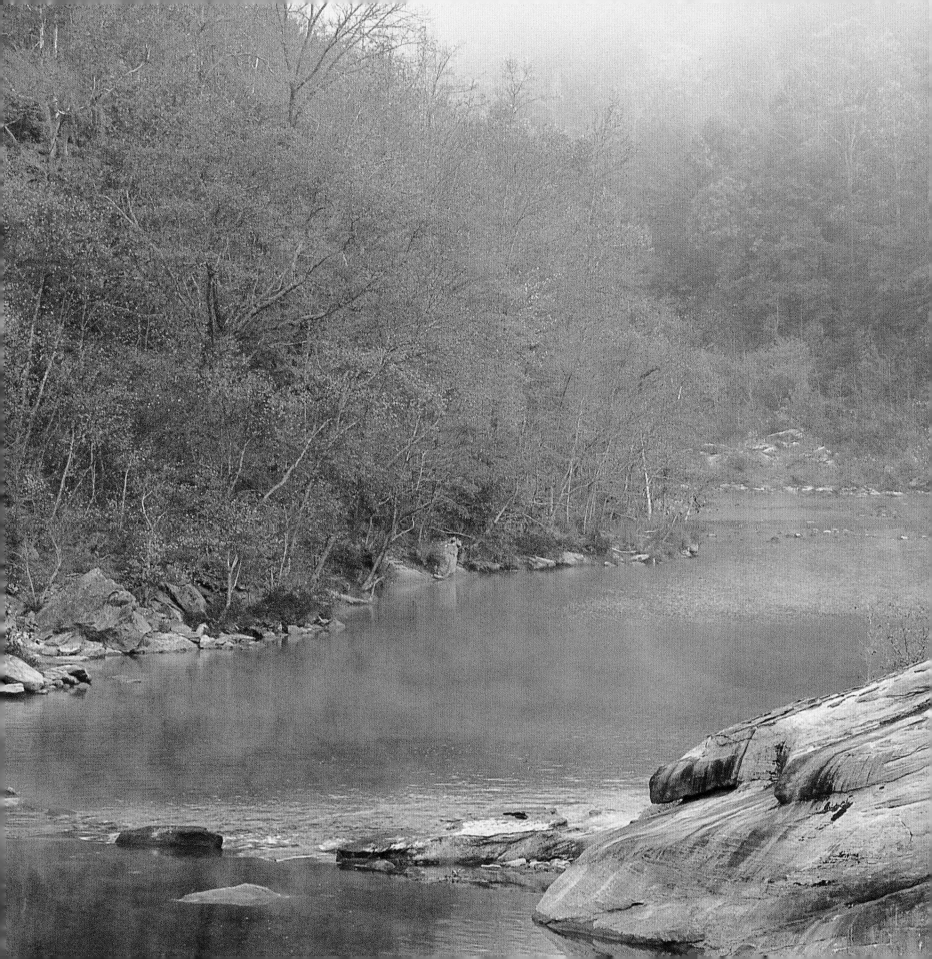

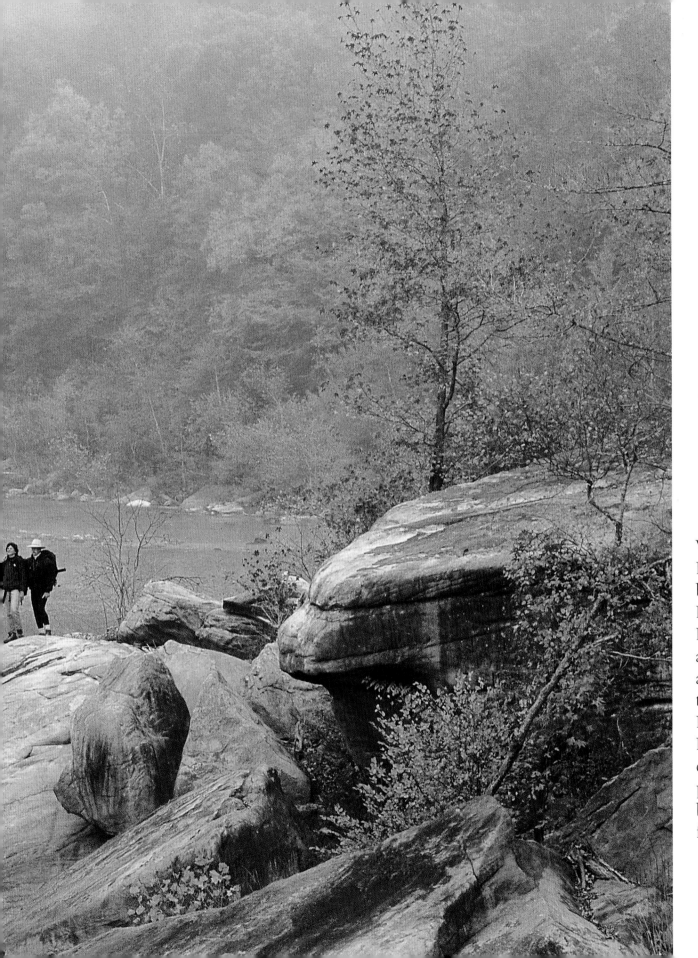

Winding along the Kentucky-Tennessee border, the Big South Fork National River and Recreation Area provides a recreational paradise along the south fork of the Cumberland River. Managed by the National Park Service, the area offers camping, rafting, paddling, hiking, horseback riding, cycling, and fishing.

Within Daniel Boone National Forest, Cumberland Falls State Resort Park protects 1,294 acres. The preserve is a haven for both nature lovers and wildlife. White-tailed deer, bobcats, foxes, beavers, and myriad bird species make their homes here.

FACING PAGE
Known as Niagara of the South, Cumberland Falls is 125 feet wide and cascades more than 60 feet into the basin below. From a dance pavilion and nature center to whitewater rafting trips, the surrounding parkland offers activities for vacationers of all ages.

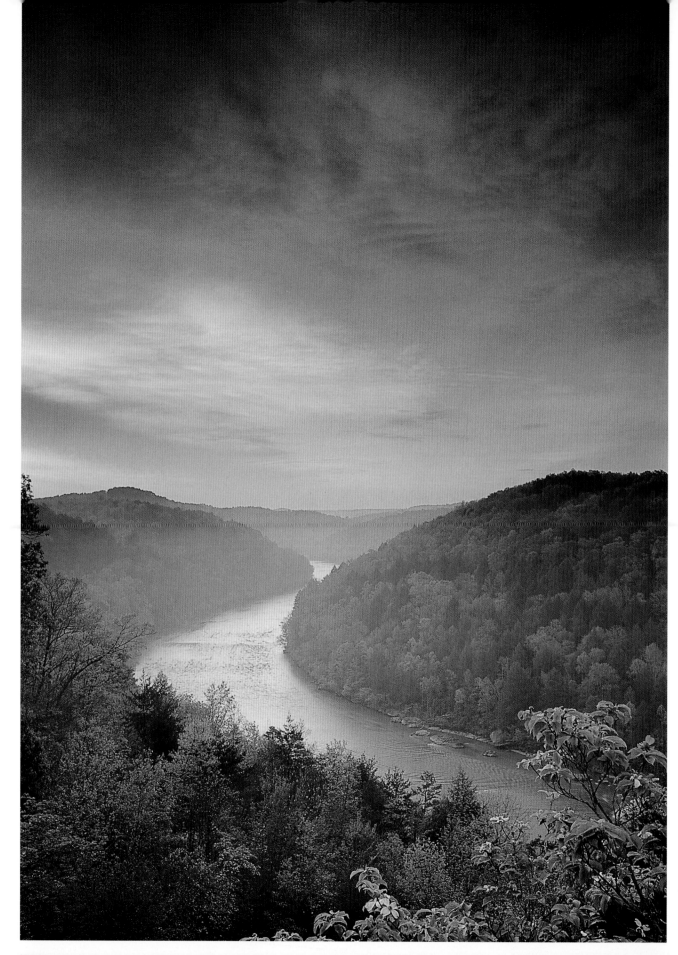

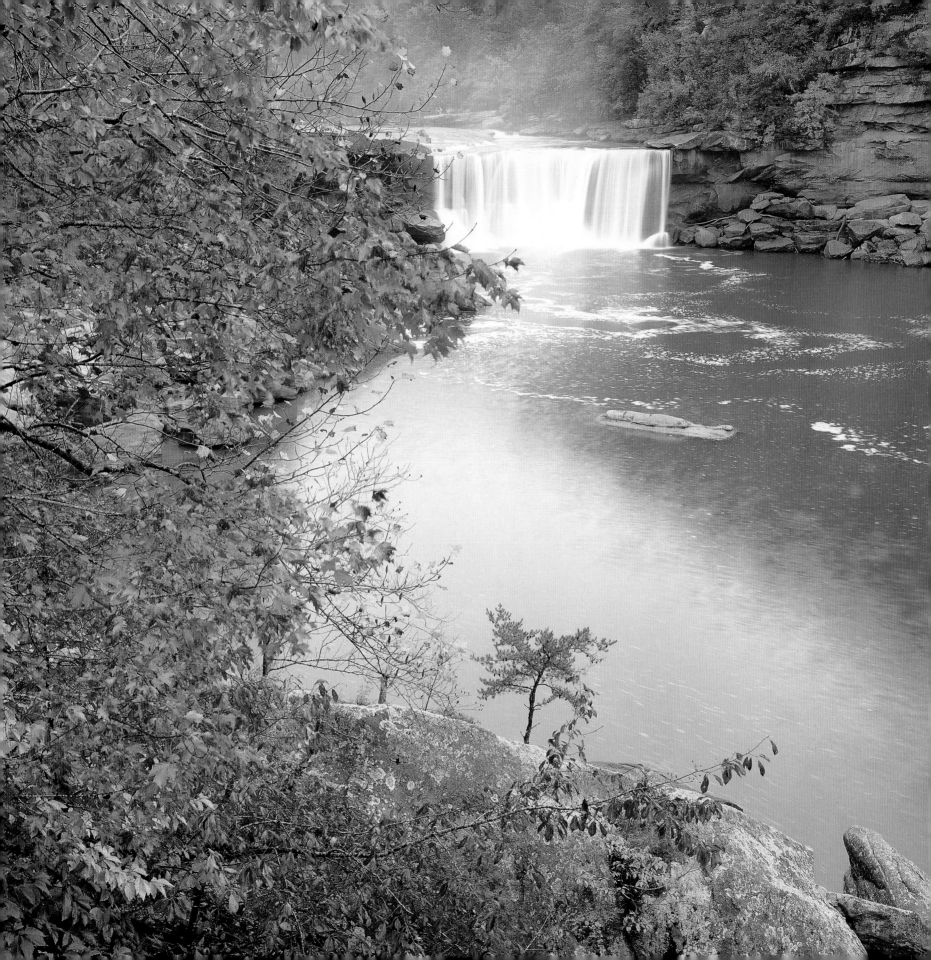

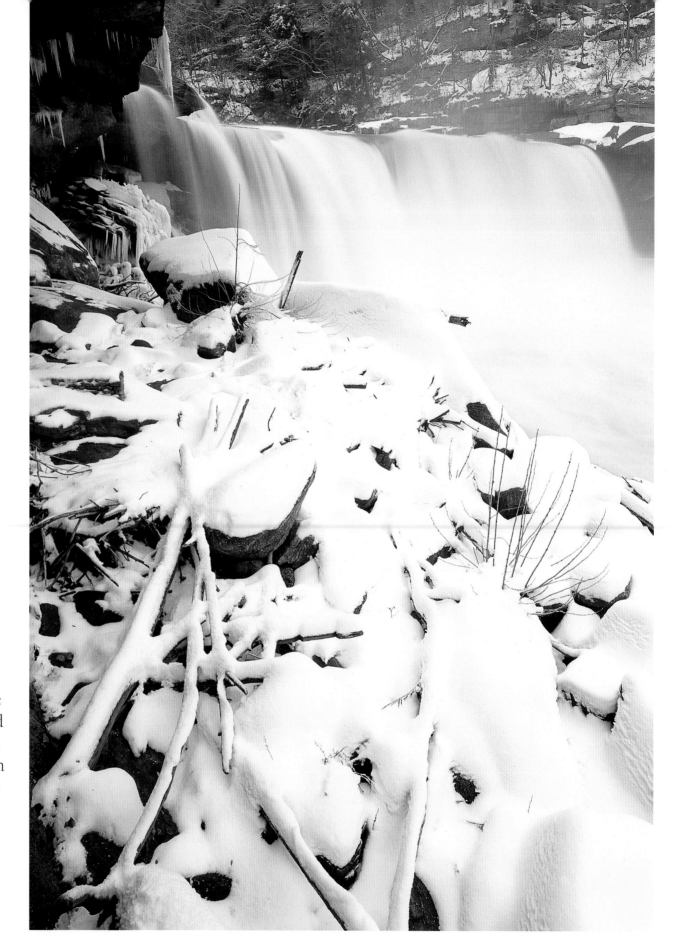

The Cumberland River is born in southeastern Kentucky, gathering small tributaries as it makes its way across the Cumberland Plateau and into Tennessee. From its headwaters to its junction with the Ohio River, the waterway drains 18,500 square miles.

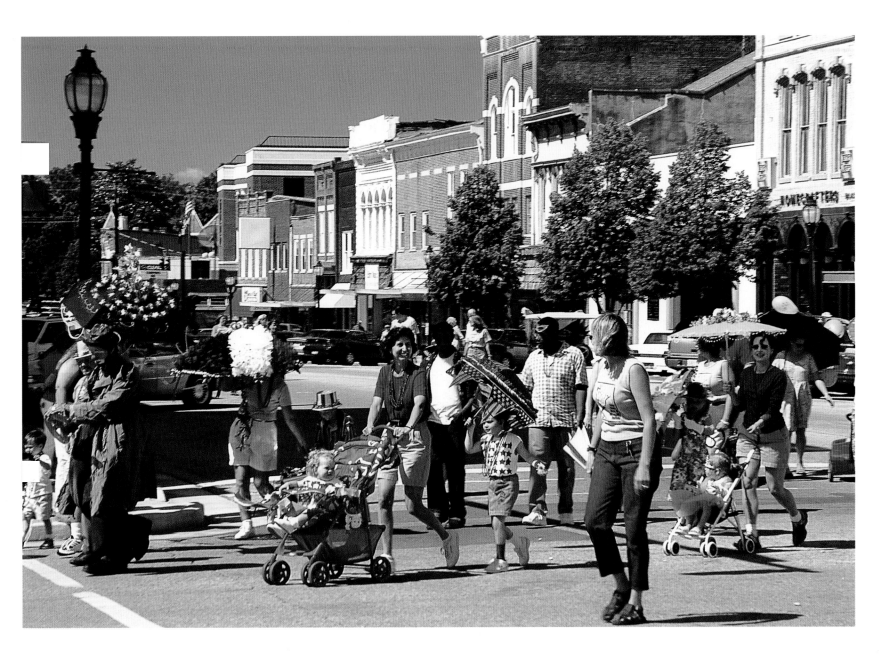

Once home to blues pioneer William Christopher Handy, the city of Henderson celebrates its heritage each summer with the W. C. Handy Blues and Barbecue Festival. Outdoor concerts, lavish dinners, dance workshops, and children's activities attract celebrants from across the state and beyond.

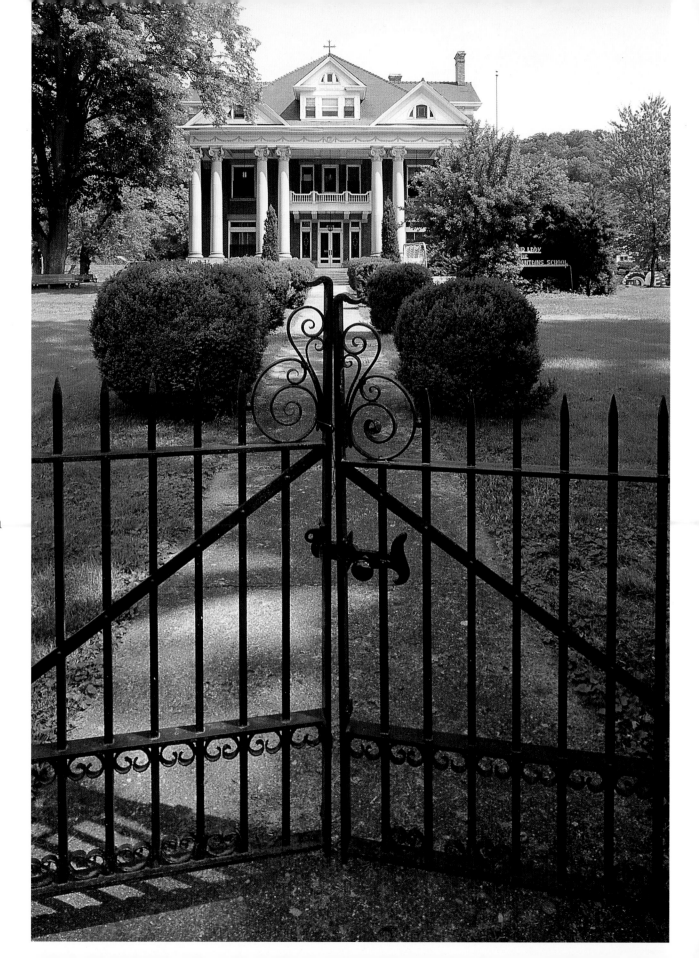

This Paintsville mansion was built between 1905 and 1912 for coal magnate John C.C. Mayo. Although he moved in the social stratosphere of the Rockefellers and Carnegies, Mayo chose to live near his mines in the heartland of Kentucky. His home now serves as a school, founded by Alice Jane Alka Mayo after her husband's death.

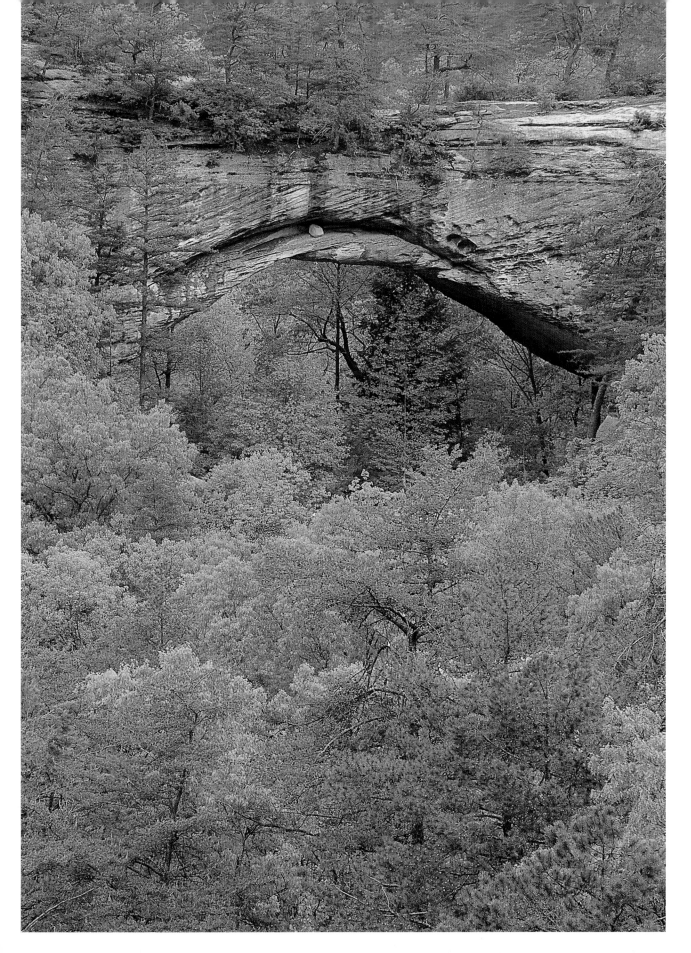

Hiking trails crisscross the 945-acre Natural Arch Scenic Area, once the hunting grounds of the Cherokee people. The arch itself appears above the trees, the sole remaining portion of a sandstone cliff that has been eaten away by erosion.

Rugged and remote, Clifty Wilderness is named for the precipices that slice through the 12,646-acre preserve. More than 60 miles of hiking trails meander through the wilderness and the neighboring Red River Gorge Geological Area, many of them leading to distinctive rock formations.

Soaring 65 feet above the earth, the sandstone arch in Natural Bridge State Resort Park spans 78 feet. Nearby cottages, a mountain lodge, a pool complex and an aerial tramway to the rock formation make this a favorite family holiday destination.

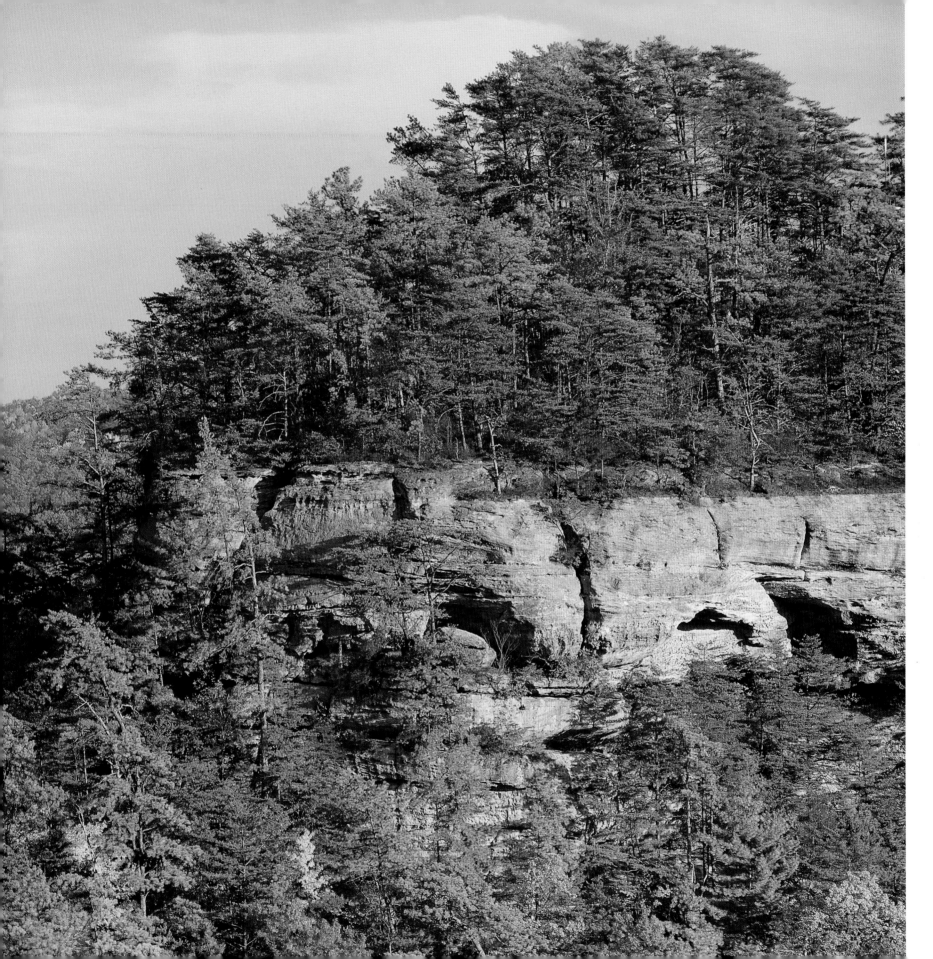

The gorges and creek-beds, forested slopes and shaded sandstone embankments of Clifty Wilderness offer varied habitat for more than 750 flowering species and 170 distinct varieties of mosses. While this crested dwarf iris is a common woodland sight, 15 rare or endangered species also flourish within the preserve.

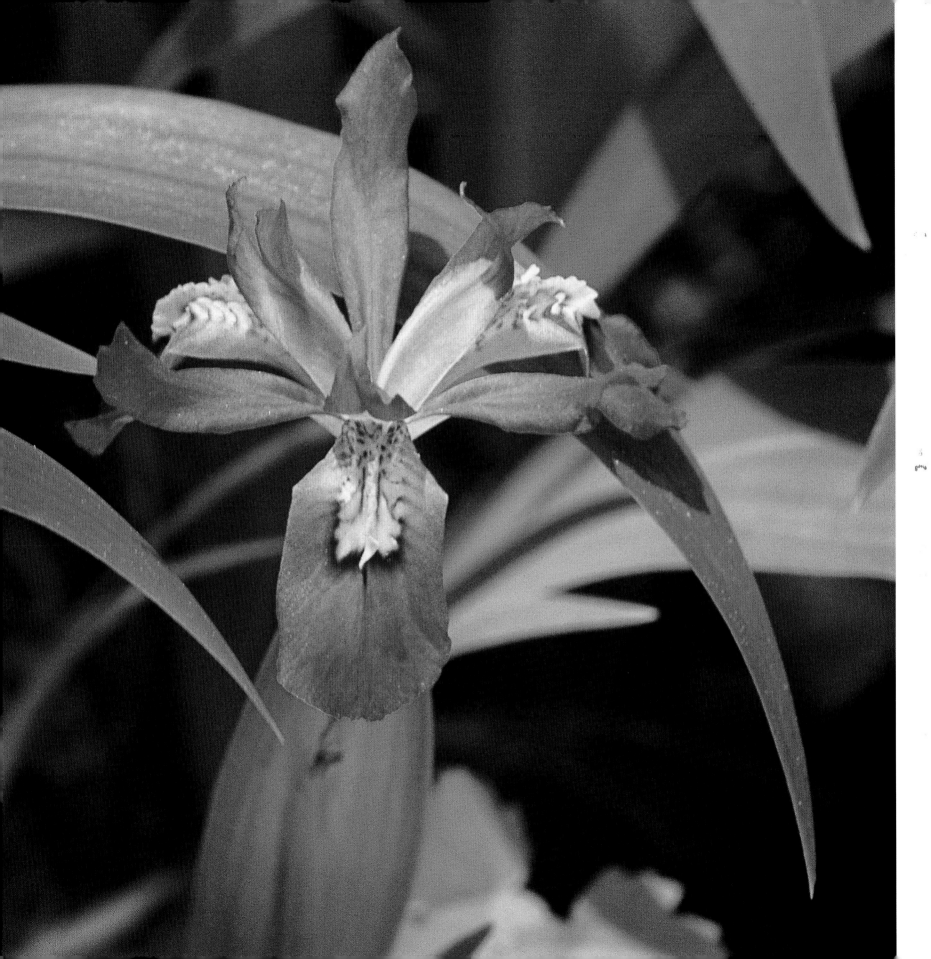

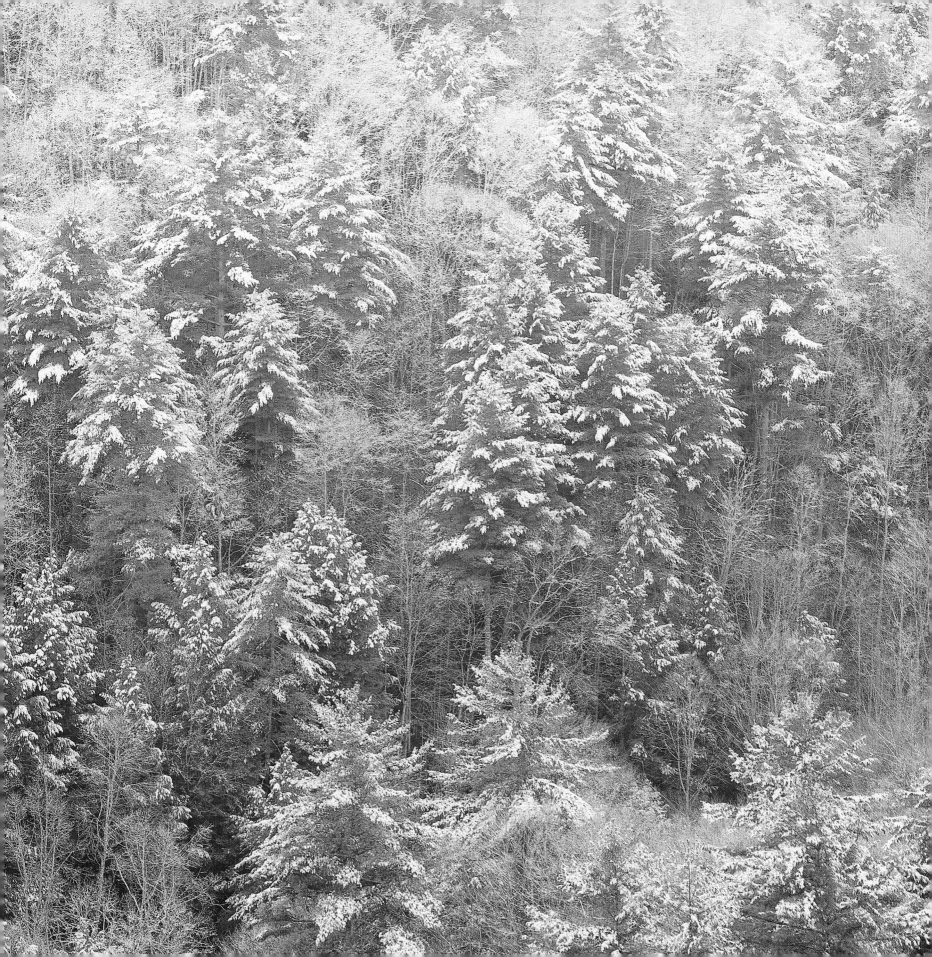

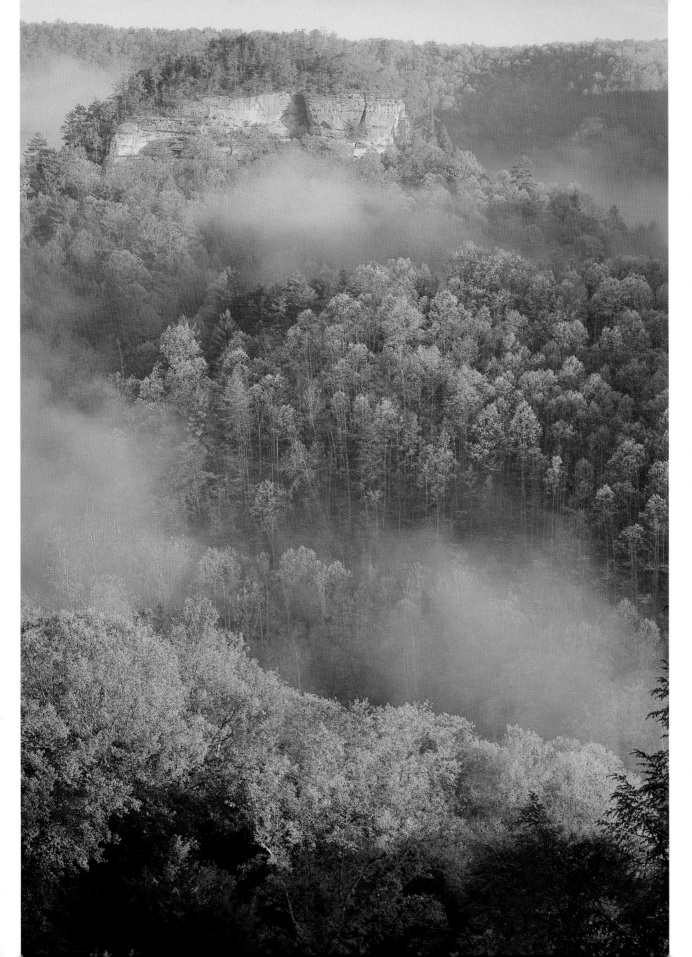

The Red River Gorge Geological Area is a National Natural Landmark lying within Daniel Boone National Forest. Wind and rain over a period of 70 million years have sculpted more than 100 natural stone arches amid the thick forest slopes. The preserve also holds signs of earlier times, from remnants left by Shawnee hunters to campsites and homesteads of early European settlers.

FACING PAGE
The 697,900 acres encompassed by Daniel Boone National Forest include two large lakes, two protected wilderness areas, and more than 3,400 miles of cliff-top precipices. The forest's boating, backpacking, camping, hunting, and fishing opportunities draws millions of visitors each year.

Brush Arbor Appalachian Homestead is a collection of restored buildings, from a cantilevered barn built in 1820 to a tiny log church. Privately funded and operated, the site was created by Jerry L. Hayes, whose ancestors were among the first homesteaders in the state.

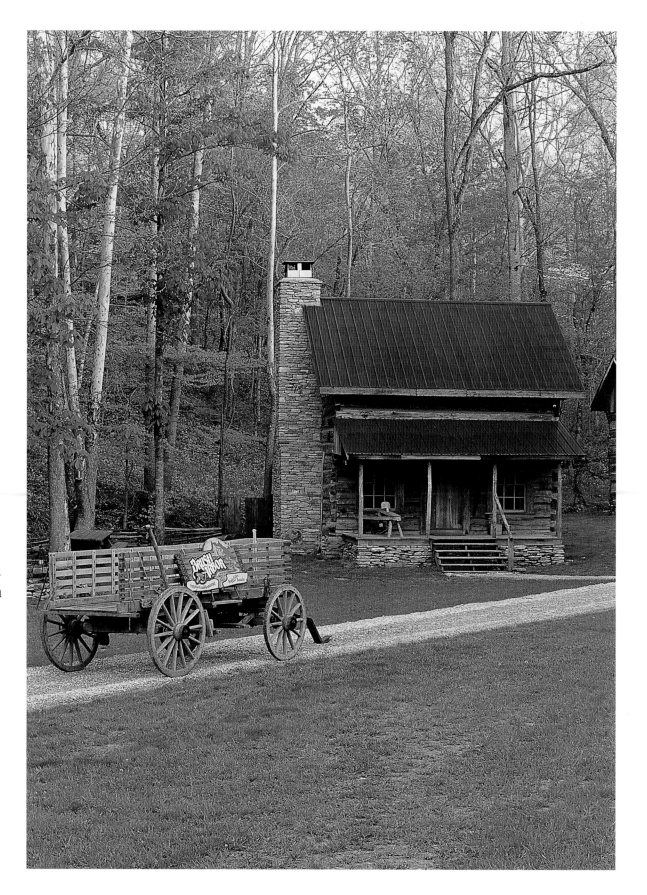

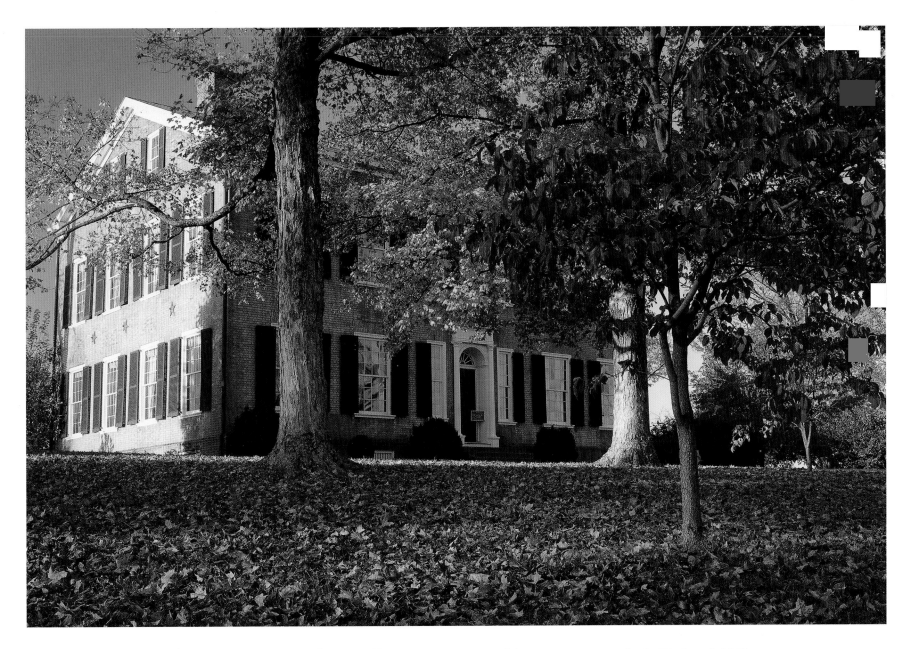

In 1852, Stephen Collins Foster visited his cousins at their Federal Hill mansion. Inspired by the experience, Foster wrote "My Old Kentucky Home," destined to become one of America's first popular songs. The mansion and the surrounding 285 acres were deeded to the state in 1922 and now comprise My Old Kentucky Home State Park.

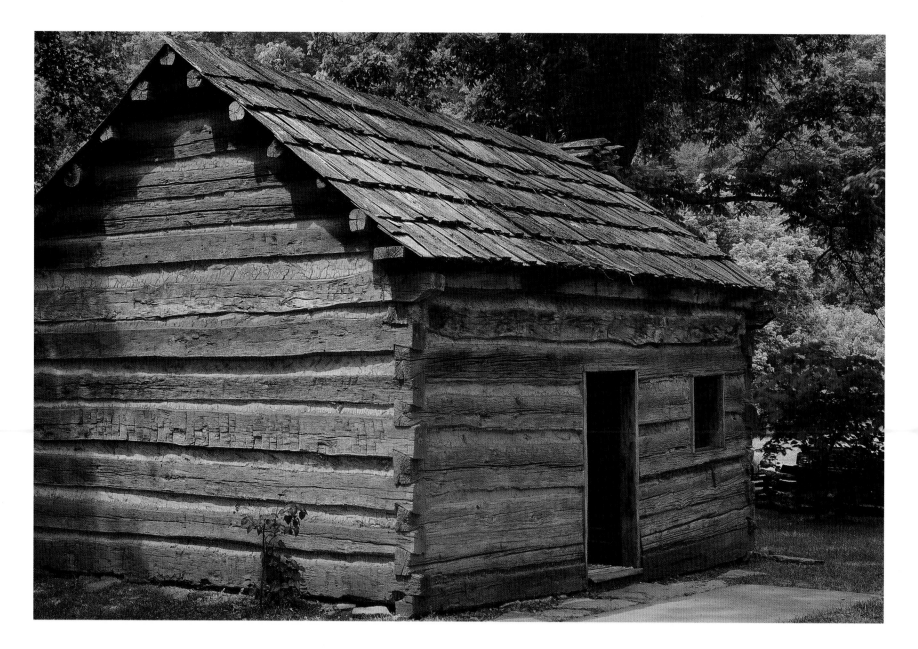

Acquired in 2001 by the National Park Service, this LaRue County farm was the boyhood home of Abraham Lincoln, sixteenth president of the United States. During his life, Lincoln spoke of the Knob Creek Farm as the site of his earliest memories. He lived here until the age of seven, when his family moved to Indiana.

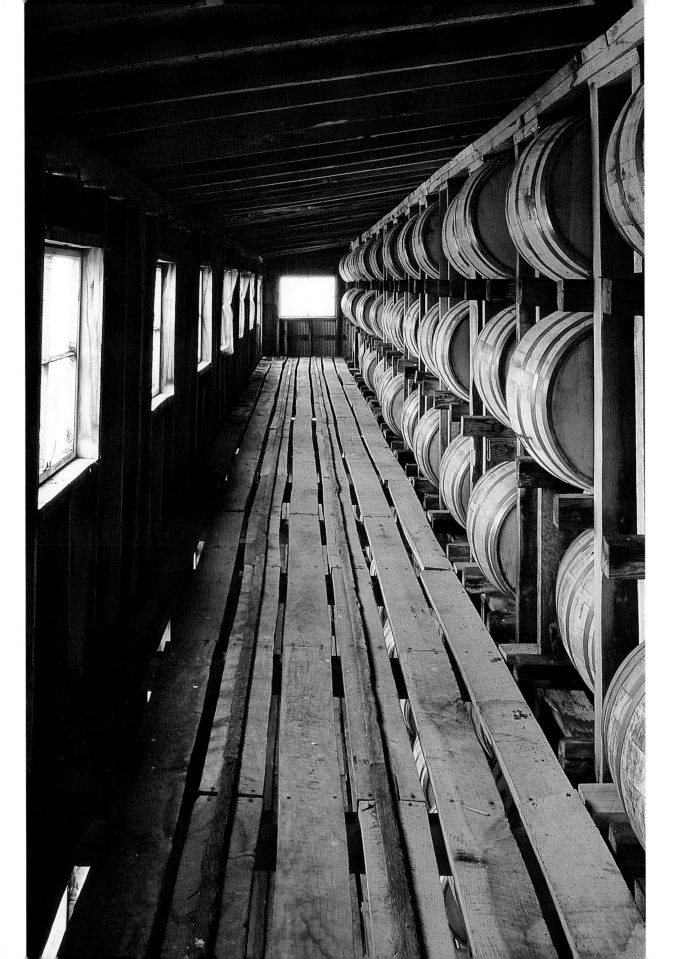

Bourbon is barrel-aged for a minimum of four years at Maker's Mark Distillery, owned by the great-great-great-great grandson of one of Kentucky's first whisky distillers. Using spring water and locally grown maize, the Loretto-based company produces small batches of what critics call some of the world's smoothest bourbon.

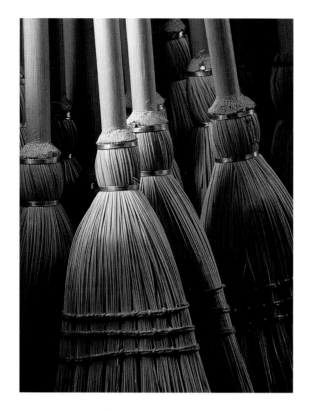

Two craft stores at the Shaker Village of Pleasant Hill offer products once made and used by the colonists. Traditional corn brooms, hand-blown hurricane lamp shades, candle stands, cookbooks, and collections of Shaker music line the shelves.

The Society of Believers in Christ's Second Appearing—better known as the Shakers—founded the village of Pleasant Hill in 1805. Born of the Great Revival movement, the evangelizing converts were also experienced farmers. At its peak, the community owned 4,500 acres. Today the village is a living history museum, where costumed staff recreate nineteenth-century Shaker life.

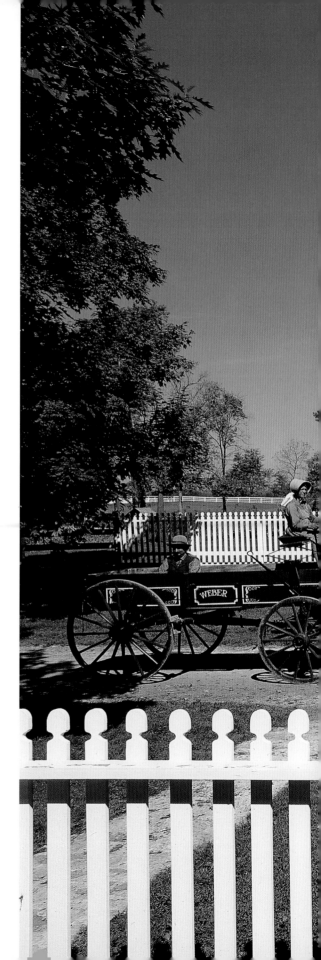

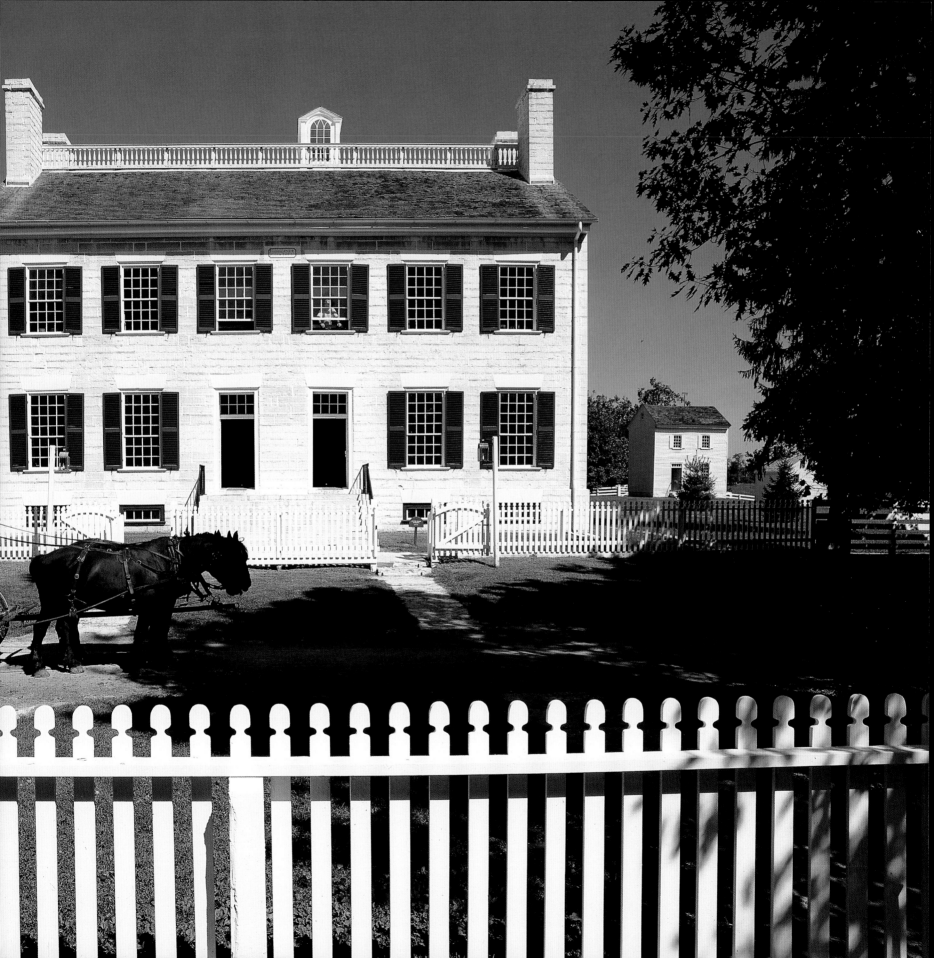

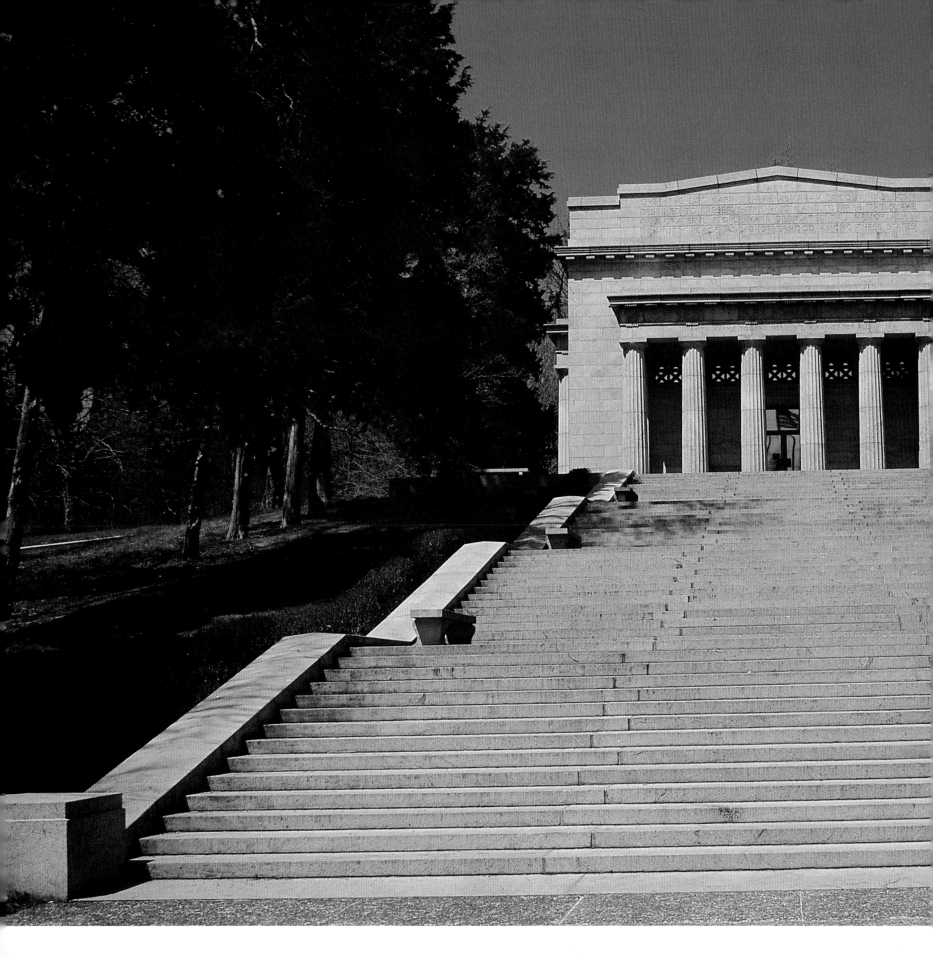

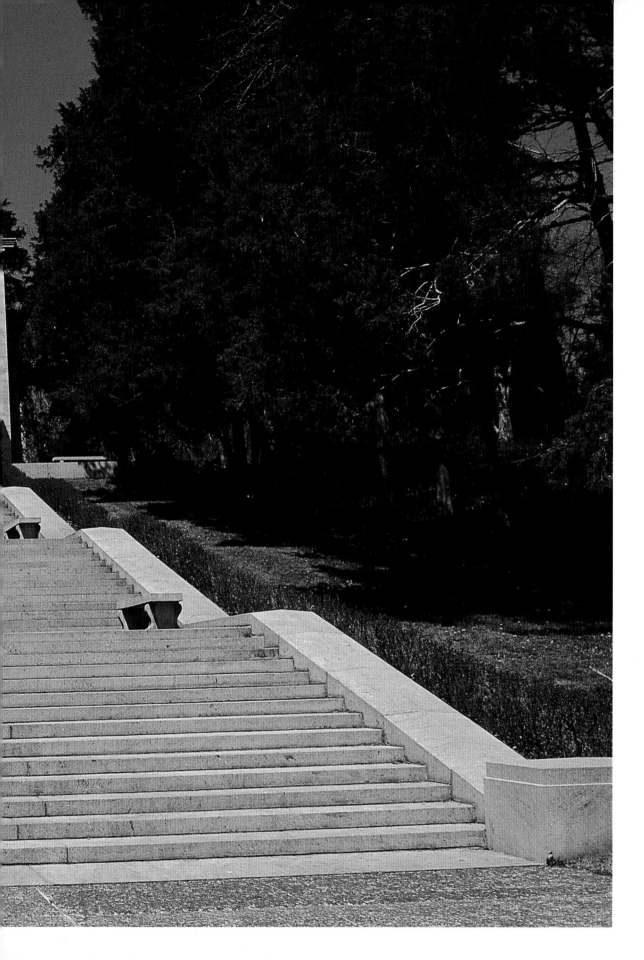

In a one-room cabin on Sinking Spring Farm, Nancy Lincoln gave birth to her son, Abraham, in 1809. Now a National Historic Site, the president's birthplace includes a memorial, an environmental study area, and the Sinking Spring itself, where a small creek disappears underground.

OVERLEAF
Poppies brighten the fields near the city of Springfield in Washington County. In the early 1900s, more than 2,000 farms dotted this region. Today there are half that number, and the manufacturing and retail sectors have grown to become leading employers.

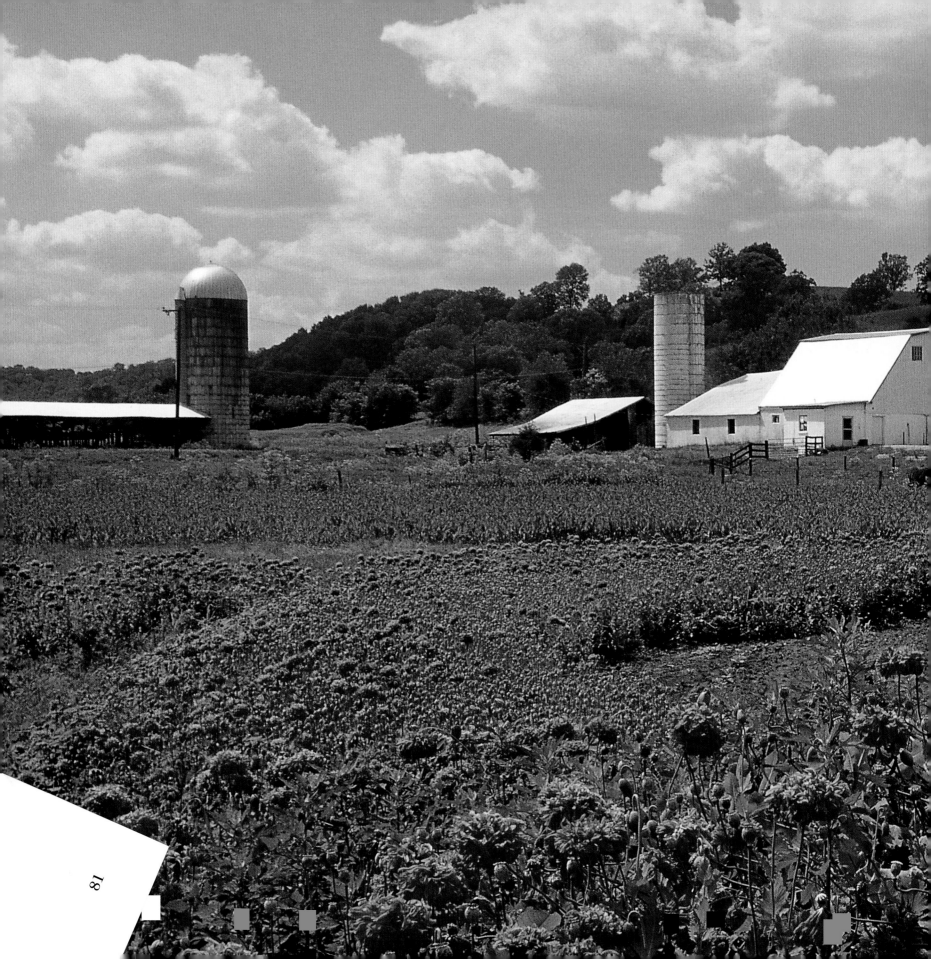

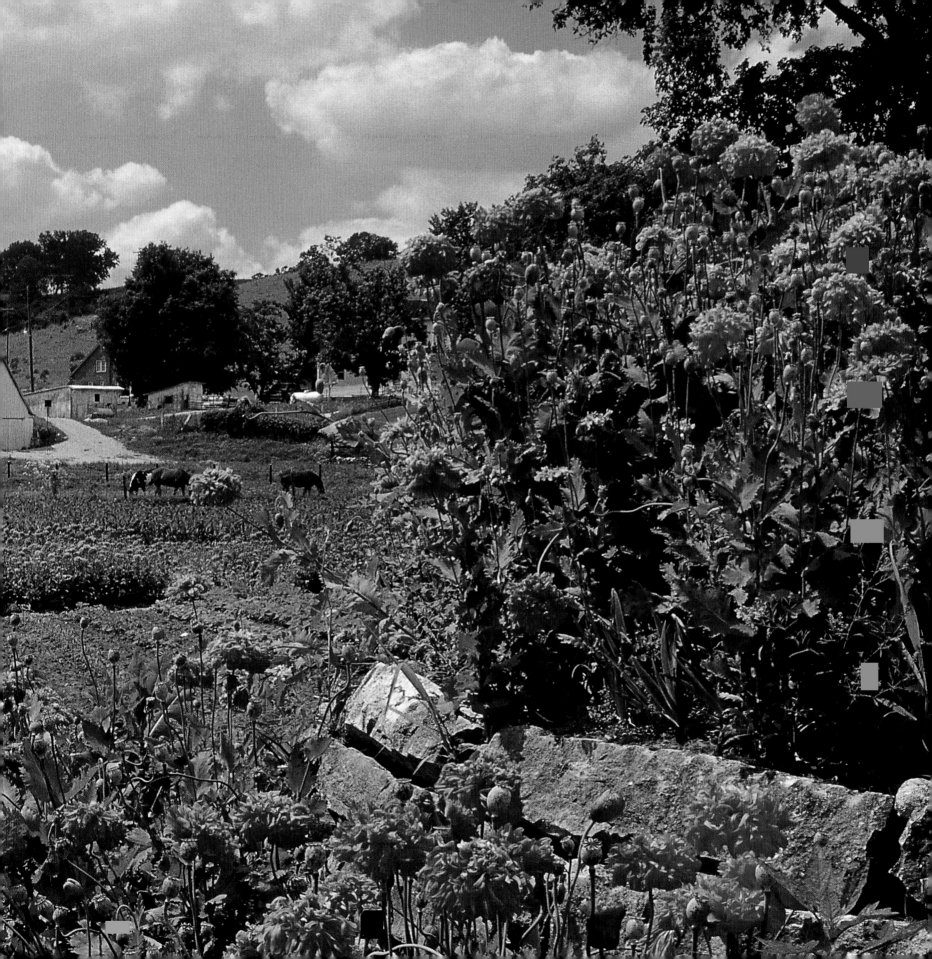

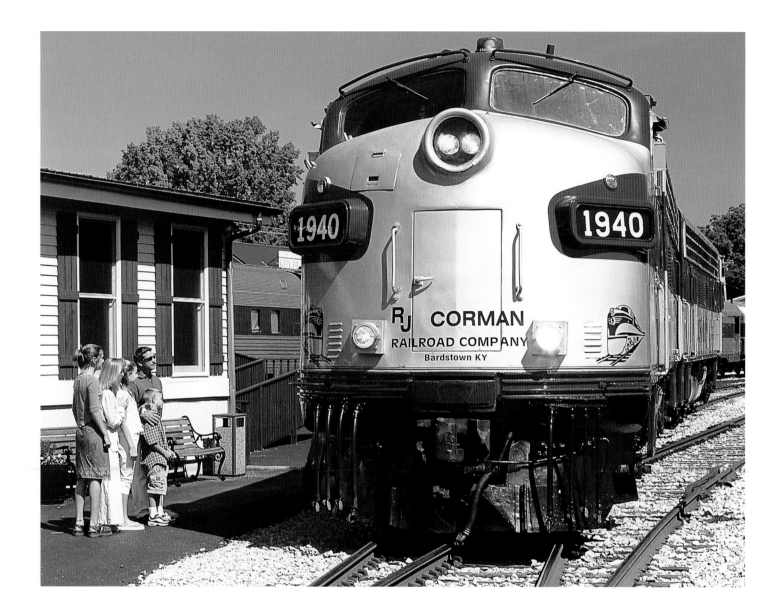

My Old Kentucky Dinner Train in Bardstown combines fine dining and vintage 1940s railway cars with a tour through the scenic countryside to Limestone Springs. The depot, built before the Civil War, is listed on the National Register of Historic Places.

Mammoth Cave National Park protects the world's longest mapped cave system— 336 miles of connected caverns. Home to eyeless fish, cave beetles, spiders, millipedes, crickets, bats, and gnats, the caves provide a unique and diverse ecosystem. UNESCO declared the park a World Heritage Site in 1981 and an International Biosphere Reserve in 1990.

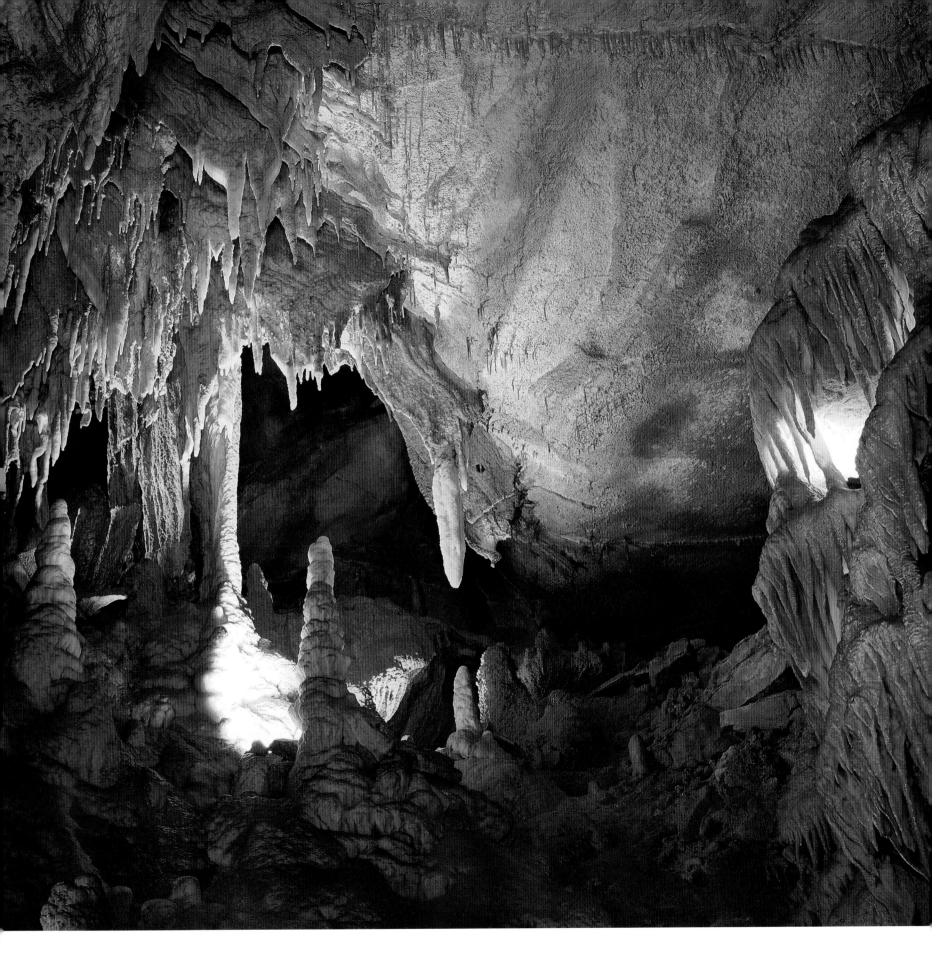

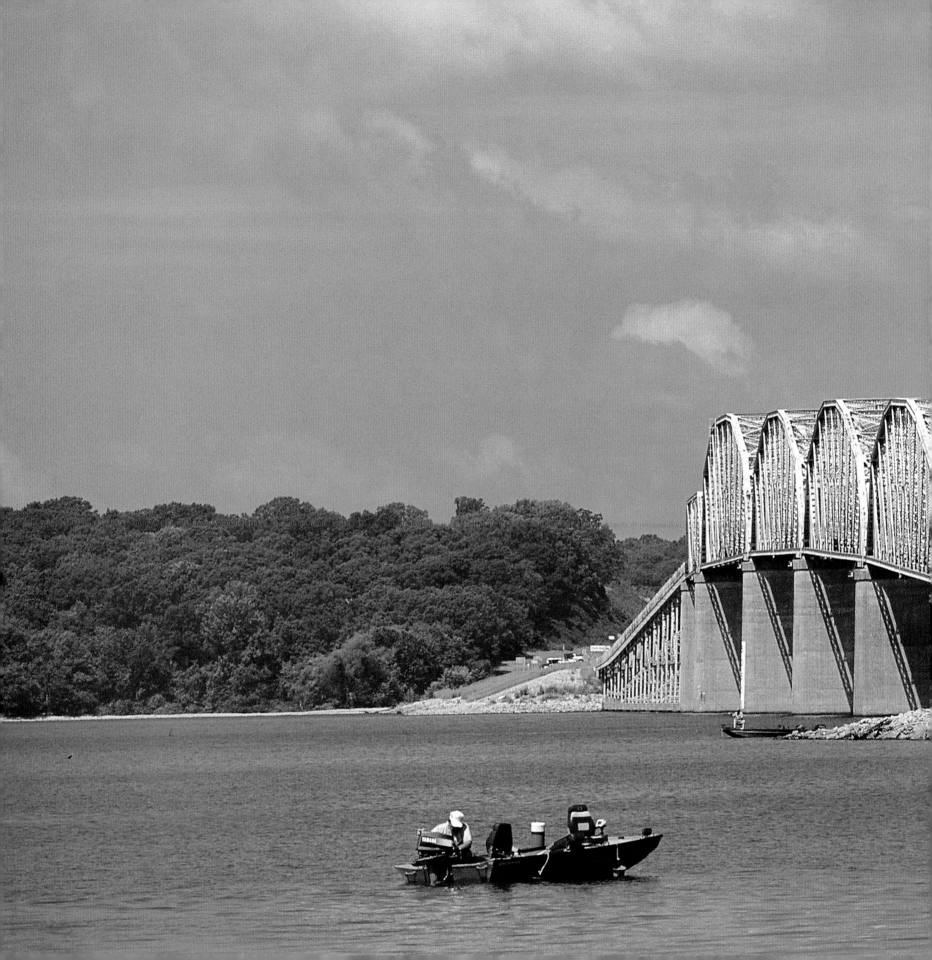

Land Between the Lakes National Recreation Area is a 170,000-acre preserve between Kentucky Lake and Lake Berkeley, both formed in the 1960s with the damming of the Cumberland and Tennessee rivers. Along with recreational activities, the land offers refuge to 1,300 plant, 230 bird, and 53 mammal species, including the largest buffalo herd east of the Mississippi River.

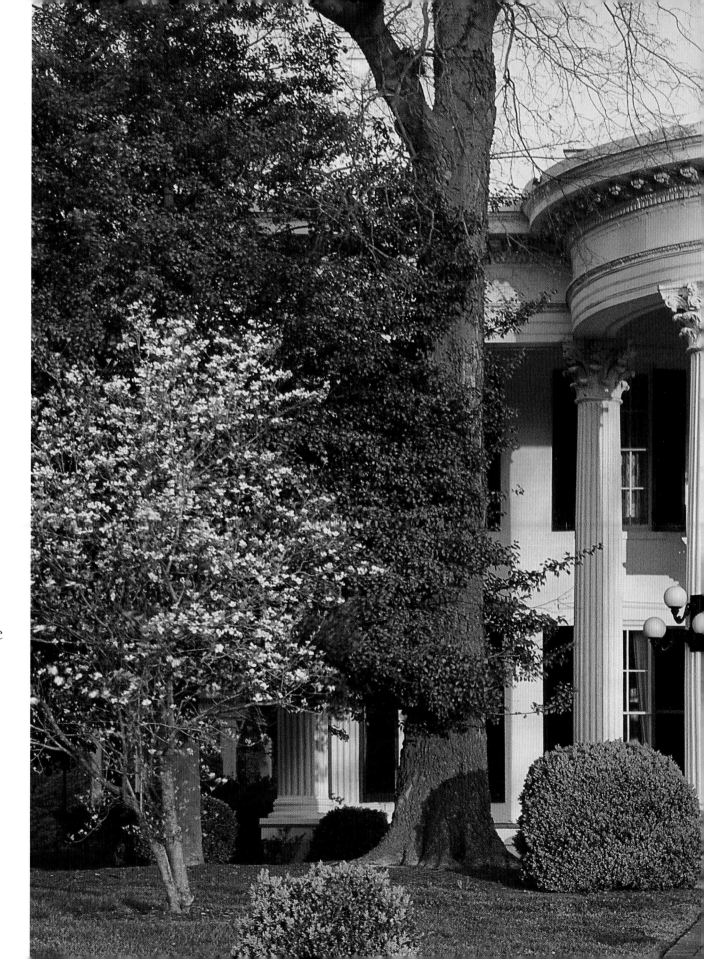

The Whitehaven Visitor Center welcomes travelers to Kentucky and the southern United States. The 1860s mansion, renovated in 1903, has been restored as a rest and information stop, as well as a museum exhibiting the memorabilia of Vice President Alben Barkley.

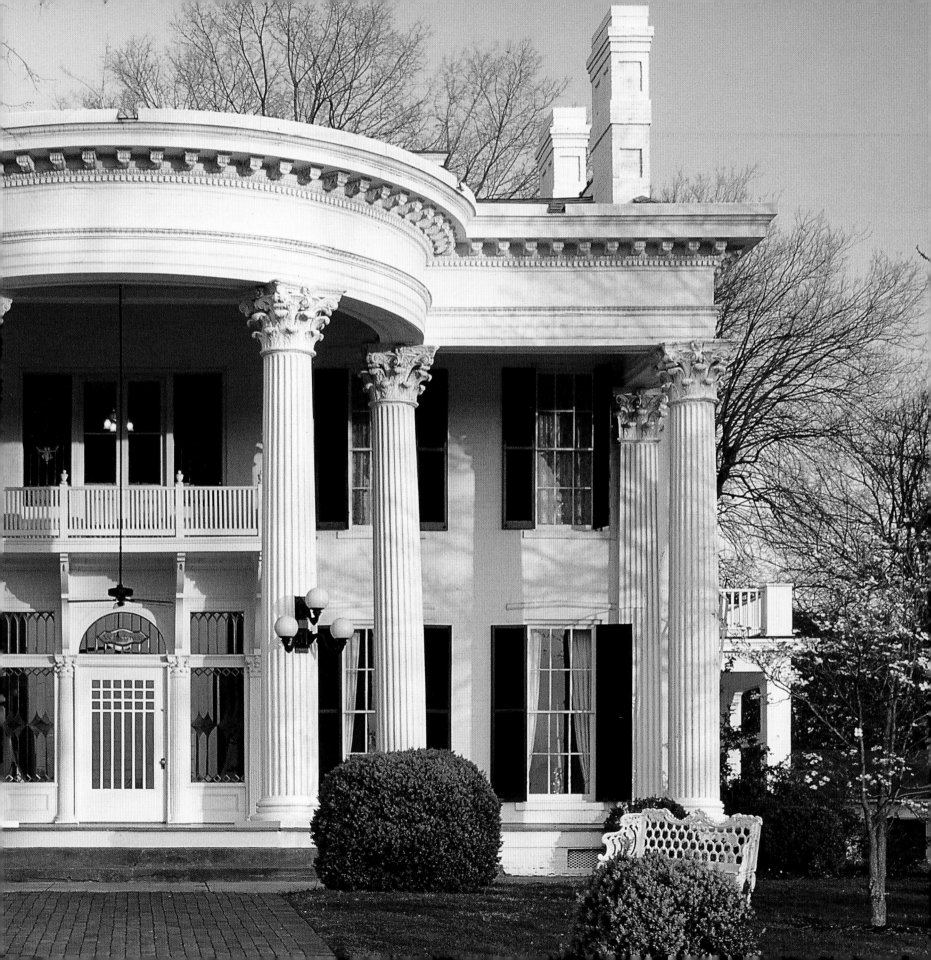

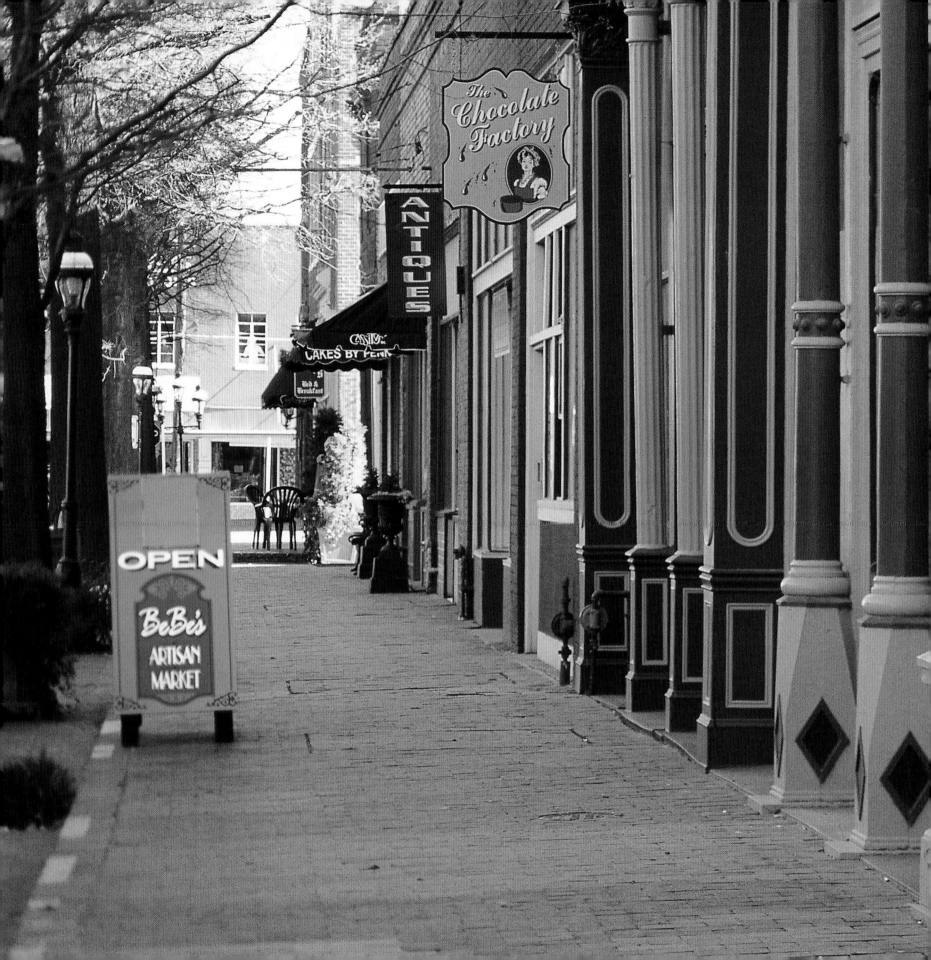

Born in the early 1800s at the confluence of the Ohio and Tennessee rivers, Paducah is named for peace-loving Chickasaw chief Paduke, whose tribe once hunted here. The architecture of the past has been preserved in Paducah's Market House Square, where horse-drawn carriages offer romantic afternoon tours and museums and galleries entertain sightseers.

Established as a ministry for sailors in 1834, the Seamen's Church Institute of New York and New Jersey has continuously expanded its mandate. One innovative project is the Center for Maritime Education in Paducah, Kentucky. Here, computer simulations are used to train sailors from around the world.

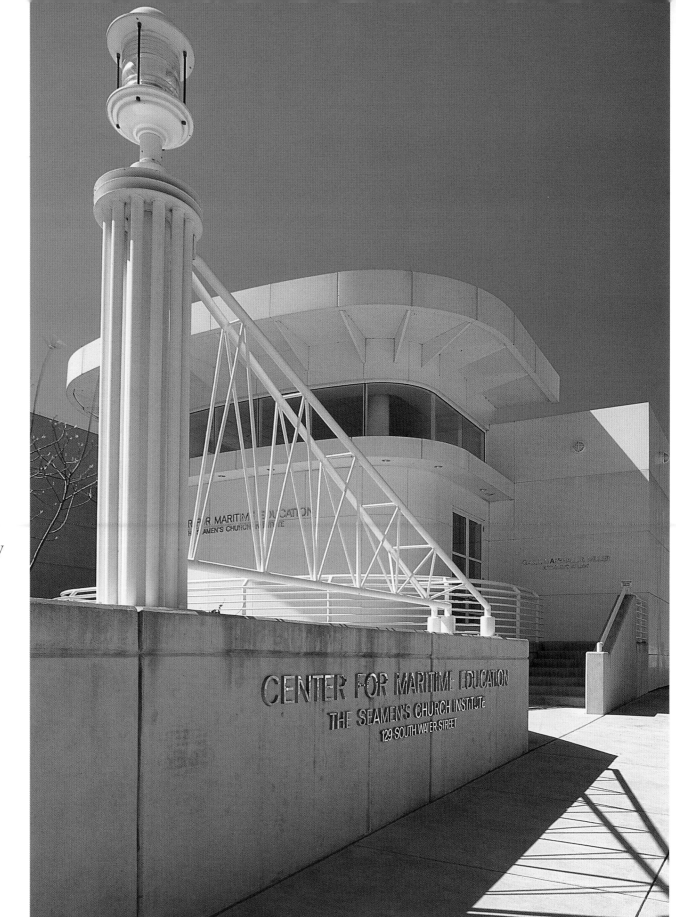

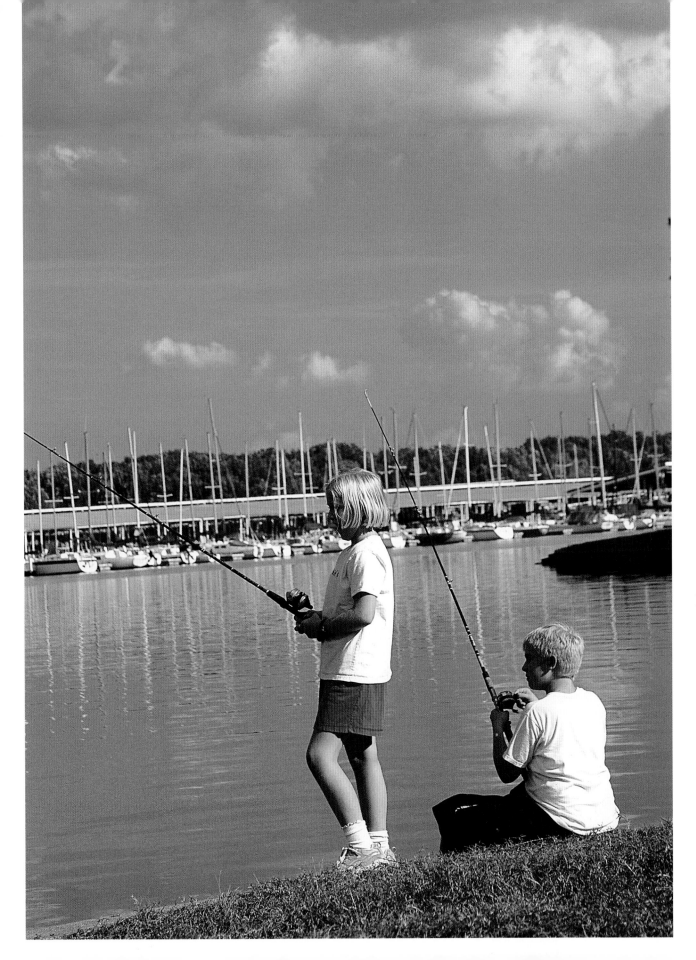

An artificial lake created by a hydroelectric dam, Kentucky Lake is the largest body of water in the state. The lure of sun, watersports, and the largest marina in the state park system make Kentucky Dam Village State Resort Park one of Kentucky's most visited preserves.

Fertile soil along the banks of the Ohio River makes the land near Owensboro ideal for crops. Much of the land here in Daviess County is devoted to agriculture, producing some of the state's highest yields of soybeans, corn, and tobacco.

Photo Credits